EVENT
PHOTOGRAPHY
HANDBOOK

How to Make Money Photographing

Award Ceremonies, Corporate Functions,

and Other Special Occasions

Published by:
Amherst Media, Inc.
P.O. Box 586
Buffalo, N.Y. 14226
Fax: 716-874-4508
www.AmherstMedia.com

Publisher: Craig Alesse
Senior Editor/Production Manager: Michelle Perkins
Assistant Editor: Barbara A. Lynch-Johnt
Editorial Assistants: John S. Loder and Carey Maines

ISBN-13: 978-1-58428-241-9
Library of Congress Control Number: 2008926656

Printed in Korea.
10 9 8 7 6 5 4 3 2 1

Preface

Event photography offers all photographers a new source of income.

The new millennium brought an exciting new dimension to the art of photography: the digital camera. In less than a decade, film-based photography has been largely replaced by a tidal wave of newer, better, and less expensive digital cameras. This amazing development has brought affordable photography to millions of consumers around the world, and the trend shows few signs of letting up. This is both good and bad news for professional photographers. The good news is that better and better cameras at lower prices are entering the market constantly. The bad news is that more consumers have access to these same cameras and are increasingly taking photographs for themselves.

Event photography offers all photographers a new source of income, despite growing competition from nonprofessionals. Event photography allows you to grow at your own speed. Although you need some basic equipment to begin, you don't need to expand your equipment until you are ready to move to the next plateau. Your success may come quickly in a small community and less quickly in a large urban environment where there are established photographers already in the market, but your individual talent, marketing skills, and love of people and photography will make a difference.

It really doesn't matter if you are young or old, male or female. You'll be judged on what you can produce.

We have operated as professional photographers for many years and recently began collaboration as the JPG Photo Events Team operating in Northern Virginia just across the Potomac River from Washington, D.C. and Maryland. Together we've established ourselves as important players in a highly competitive market.

We are sharing some of our insights into event photography in hopes that it will give readers a realistic view of both the positive and negative sides of the business. It will outline specific plans that you can use to build your own business. We'll point out some pitfalls, and we'll hopefully encourage each reader to try and enter this business.

TECHNICAL NOTES

We both use Nikon cameras almost exclusively, and all of the images in this book were taken with Nikon digital cameras. We both bought new Nikon D3

and D300 cameras as we were in the final stages of writing this book, and we've both been very impressed with the results we obtained at our final event for 2007. Nikon products produce outstanding results, and we believe that Nikon shares as much credit for our photographs as we do.

There are a few other brand names of equipment or suppliers that we have cited in this book because we've found these products to be helpful. No endorsement of any manufacturer, company, association, product, service, facility, or web site is implied or given. Omission of any of the above neither implies nor connotes anything negative about their product or service.

As you read through this book, you'll notice we've tried to keep things as simple as possible. Photographing anything, for a newcomer, is difficult. Photographing events with all kinds of new people can appear impossible. So, we've tried to make it easier to begin to understand what photography is all about without getting too technical. We hope this approach proves valuable.

McLean and Vienna, VA
January 2008

Photographing events with all kinds of new people can appear impossible.

ACKNOWLEDGMENTS

Our respective wives, Carole and Dorothy, deserve a lot of credit for putting up with us while we head off for one assignment after another. Putting up with a spouse who is a photographer is always a challenge, and to their credit they do put up—and with good grace.

We also need to acknowledge Craig Alesse's help in publishing this book. Craig is the publisher at Amherst Media, and the fact that this book was published is because of his support, encouragement, and willingness to put up with delays.

Contents

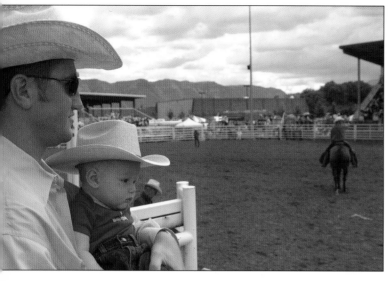

1. Finding Customers

Finding, making, and keeping customers is an art form. Some photographers excel at this critical component of business, while others find attracting and keeping clients difficult. Our marketing program includes several components, which are designed to help us meet our goals. These components are detailed in this chapter.

A POSITIVE OUTLOOK

Your attitude toward people is probably the single most important factor in attracting and keeping clients. If you really enjoy working with people, you'll

These are some of our clients who know and appreciate our work.

Your positive attitude reflects onto your subject.

If you are simply out to make a quick buck, you'll likely have a hard time.

find it increasingly easy to expand your customer base. If you tend to be uncomfortable around people, or if you expect them to put up with your idiosyncrasies, or if you are simply out to make a quick buck, then you'll likely have a hard time in event photography.

So, what sets us (we operate as the JPG Photo Events Team) apart from other photographers? If you watch Jim in action, for example, you'll quickly understand that he genuinely loves photographing people, and his intense interest in his subjects as individuals results in them responding with genuine pleasure at being photographed instead of the stiff, "say cheese" look we all expect. Because we have a sincere interest in photography and people, we attract and keep customers.

In fact, like many successful businesses, we depend on enthusiastic clients who are surprised at the quality of our work and refer us to their friends and associates. This is the best kind of advertising, and it doesn't cost a cent.

TECHNICAL AND BUSINESS COMPETENCY

We are both technically competent having photographed for many, many years. We use a Mamiya medium-format camera with a digital back for studio work and Nikon camera equipment and Nikon and Quantum flash systems for our location assignments. We both operate Mac Pro computer systems (Jim is far more knowledgeable than I am in many facets of computer technology, but he ran an IT business). We both understand business and feel relaxed talking to CEOs and businesspeople. We believe in the value of our photography and are not reluctant to discuss our prices. These traits are common to various degrees among all professional photographers.

A MARKETING PLAN

A positive attitude and a good marketing plan will quickly establish you as someone special . . . someone to contact when the need arises. Jim Goodridge and I have photographed as a team for over a year, but during that time we've made tremendous progress in a market that is crowded with very good photographers. We also have a dynamic marketing strategy that evolves and improves each time we complete an assignment. After every assignment, we review the results and select the best images to refresh our marketing pieces.

PORTFOLIOS

Keeping a portfolio of your best shots is essential to success. You must be able to demonstrate that you have been there and done that. A good portfolio attracts interest and customers; a poorly organized, outdated portfolio will cause clients to lose interest.

After a bit of experimentation we've settled on a large, leather portfolio holding 13x19-inch prints. We keep the number to twenty prints or less. The portfolios are tailored to specific clients (weddings, engagement, glamour, portraits, children, events, etc.). We also keep a smaller portfolio in our cars; they cover a variety of subjects, just in case we meet someone on the road.

Keeping a portfolio of your best shots is essential to success.

FLYERS AND MAILERS

I used to include a complimentary flyer with submissions I made in my stock photography business, but they were expensive to print, used up a lot of space, and seemed to quickly be out of date (new phone line, new fax number, etc.). Since the world has moved so quickly into the digital age, we can now accomplish the same task much faster and with pinpoint accuracy by submitting digital albums online.

Having said that, many very successful photographers still produce and distribute samples of their work by mail or at shopping malls where they exhibit their work. So, complimentary handouts are still a viable option.

WEB SITE

Our two web sites (www.wfolsom.com and www.jpgphotoevents.com) are our best sales tools. They remain available twenty-four hours a day, seven days

We photographed this golf course in autumn, expecting to receive work the following summer.

a week, and three hundred and sixty-five days a year. My web site usually receives two hundred hits a day. That translates to seventy-three thousand hits per year. Many are just lookers drifting from one site to another. Others are interested in attending my photography classes. There are always a few clients checking out photographers for an assignment, and those are the ones we want to impress.

Since Jim and I both operate independent web sites, we pick up inquiries that the other may miss. We are both registered with many event, wedding, portrait, and other web sites that steer customers our way.

E-MAIL

We consider our respective e-mail systems as especially useful tools. It's important to have a professional look to your messages. We make certain we spell-check our outgoing e-mails and keep messages to a minimum. If additional information is needed, then it goes as an attachment. We frequently include a "portfolio book" of our work as an attachment for clients to review and that book almost invariably helps us clinch an assignment. One reason is that each "portfolio book" is aimed at a specific customer. For example, when we receive a request to photograph a golf tournament, the "book" will feature stunning golf shots.

LINKS

If you can add just one link a day to your web site, you'll have a significant number of legitimate contacts by the end of your first year. Don't bother trying to fool spiders by linking your mom's web site to yours—it won't work. Make an effort and you'll be surprised at how easy it can be.

I have links with Kodak as part of their support to professional photographers, but I also have links with much smaller organizations. If you enter "Your State + photographers + event photography" into a Google search engine, you'll likely come up with a pretty good listing of sites that cater to event photographers. Try registering with those sites that appear at the top of your search list.

ADVERTISEMENTS

One advantage of being a photographer is that you always have unique photographs available for publications. I frequently receive telephone solicitations to advertise with this or that community program, charity organization, advertising campaign, or whatever. I'm always happy to receive those calls, because I quickly say that I will be glad to donate a cover for their publication,

A typical Chamber of Commerce event that I photograph.

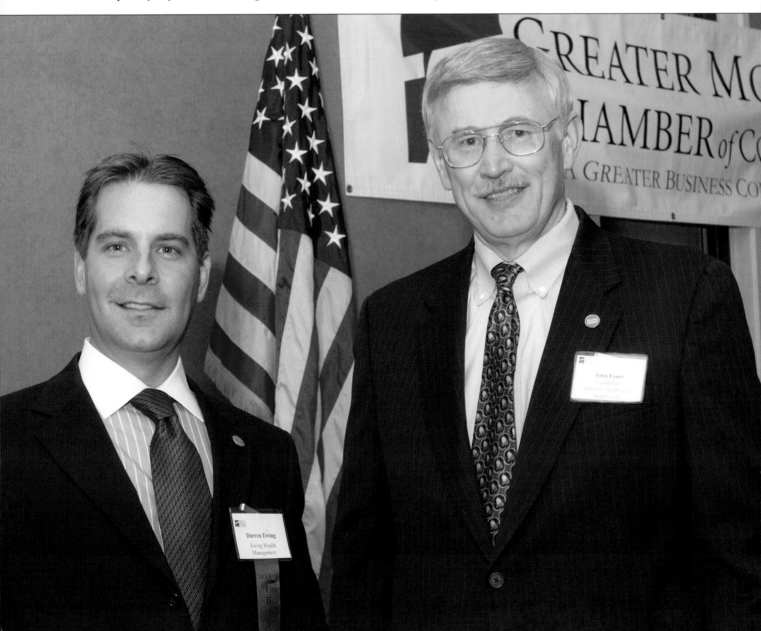

in exchange for free advertising. What do I have to lose? Very little. I get another cover credit and a free insert. The worst that can happen is that I might have to go out and photograph something specific for their event. (For example, if it involves a golf tournament, the organizers might want a photograph of the club house on the cover—something I'll be glad to do.)

VOLUNTEERING

Jim and I probably donate our time to twenty-five different charities during the course of a year. Sometimes these efforts simply don't pay off; other times we can generate follow-up sales with the organizers for future events. When we volunteer to do an event, we'll show them how they can make money by having a photographic team at their event taking images, processing them, and selling prints on the spot. Sometimes we'll do it pro bono and will allow the charity organizers to keep the profits, with the provision that they cover our costs next year. Once they see how easy it is for us to help them generate income, they are usually a lot more interested in discussing using our paid professional services for future events.

I was approached by my local Chamber of Commerce many years ago and was asked to take photographs of their newly elected board of directors. I undertook that assignment and was paid. A second assignment followed, but instead of payment I asked to join the organization as their photographer. I have since photographed several hundred chamber events at no cost. The reasons? Constant practice in a variety of complex meetings, golf tournaments, and galas. Constant exposure to some terrific businessmen and women who know me and who will refer customers my way. Constant publication of my photographs and byline in chamber newsletters. It also gives me access to a "lead share" group that meets monthly to pass along tips and business leads. It is a total win–win situation.

AT AN EVENT

We make it a habit to offer the organizers of a charity event a special door prize or an item they can use in their raffle. Usually we offer a free portrait session. We'll use some of our best images and will print up a 17x22-inch poster and mount it for display. We make sure that it is visible and it stays at the event throughout the evening drawing potential customers in without any further effort on our part. If someone signs up for a sitting, we have a potential customer to contact after the event. Silent auctions usually attract five to ten bidders and only one will win, leaving us with quite a few prospective clients.

We carry business cards. It may sound odd, but many photographers go to an event planning to shoot, shoot, and shoot. They don't stop to think that someone may have a wedding coming up or a special anniversary and that giving them a business card and offering to follow up is an ideal way to market yourself.

We dress alike with the JPG Photo Events Team logo on our shirts. We also keep a portfolio in the car, just in case someone has a special interest in

Jim and I probably donate our time to twenty-five charities a year.

Our offer of a free photo session is prominently displayed at a charity fund-raiser.

one or more aspects of our photography. Depending on the assignment, we may show a prospective client some images after the event is over. We are very careful not to openly market ourselves while we are supposed to be photographing: that would be very unprofessional and would quickly lose us customers. However (and this is a great tip), people frequently come up to us and ask how they can see or purchase the images we've just taken. When this happens, it is a perfect opening for you to direct people to your web site with instructions on how to see the images. Offer them a business card and ask if they will give you theirs. Make sure you follow up with an e-mail asking if they were able to locate the images, and offer your services for their event. It sounds simple and it is, but you must be disciplined enough to follow through after each event; otherwise, you are just collecting business cards and not generating sales.

OTHER EVENTS

As part of our marketing effort, we try to participate in events we are not directly involved in. How? We receive many invitations to participate in events, generally as a paid sponsor. Instead of declining or discarding the invitation we frequently offer the organizers a raffle item or a door prize with the requirement that we be listed as an in-kind sponsor. It frequently works. If not, our prize is out on the silent auction table or is announced as a prize during the raffle. In either case, people get to hear our name and we hope to receive one phone call from an interested client. It doesn't always happen, but our exposure is good and our costs are minimal.

TARGETING CLIENTS

We live in the Washington, D.C. metropolitan area where hundreds of conventions, meetings, birthdays, retirements, and other events take place every day. However, that does not mean that we have all the business we can handle. Thus, from time to time, we'll undertake an effort to pinpoint a specific event or event organizer to see if we can break in. We normally communicate by e-mail and offer competitive pricing and samples of our work to generate interest. Sometimes this approach works, but not always.

PLAN FOR THE FUTURE

I have a photographer friend who started off helping take to photographs at the World Bank quite a few years ago. Today she is invited to take photos at all of their annual meetings, and they will fly her around the world to take those photographs. She earned her position, and until she decides to retire, it will be very difficult to step into her territory. Fortunately, there is an ebb and flow to the business: photographers retire, organizers are assigned new duties, and so there is always the chance that a new job will open up. If you maintain a positive outlook and can stay in touch, you might be the first in line when an existing photographer gets married, finds a new job, moves, or retires.

When a new opening comes up, we respond by requesting a one-on-one visit, and we go armed with a twenty-page portfolio of our freshest and absolute best images. We dress for business, we speak the language of business, and we generally succeed in meeting our objectives.

FAILURES

We've also had our share of marketing failures. One of my biggest failures has been my inability to create assignments with the federal government. I was encouraged to go through the process of becoming a certified federal contractor. Hundreds of hours later having jumped through incredible, mind-boggling hoops, I thought I had arrived; all I did, however, was generate a flood of new spam messages from firms offering to show me how to do business with the federal government. I was then informed that I had to fill out an additional eighty-page document and submit a bid document to become registered with the government. Eighty pages were required for small busi-

We try to participate in events we are not directly involved in.

nesses! I have the greatest admiration for those photographers who perservered and are listed on the government schedule as official vendors.

If you are unable to develop a business relationship with someone or an organization, don't despair. Sometimes there is a logical reason (they already have a professional photographer who does their work), sometimes illogical (they will buy a camera for cousin Joey's birthday, and he'll take pictures), and sometimes you'll never know. Many clients, frankly, simply don't place a value on good photography.

SUMMARY

Finding customers is complicated and frustrating at times. Some people are simply not interested in photography. It's tough trying to convince some people to hire you to photograph something that might not be all that important to them. So be prepared for setbacks, but with each new job you'll develop more and better marketing tools and strategies for finding and keeping new customers.

> Finding customers is complicated and frustrating at times.

ADVICE FOR BEGINNERS

It is sometimes daunting to implement a program like the one we've outlined, but you have to start somewhere. Think small at the outset and slowly grow your own marketing program. For example, volunteer to take photographs at the local high school . . . sports and social events. Does the fire department need photographs of its volunteers? What about a local civic organization?

DAR? VFW? Lions Club? Moose Lodge? Does a local church need help? The key is to get started and learn to take photographs in a variety of conditions. Eventually, someone will ask you to take pictures of an event for a nominal fee, and, just like that, you'll have entered the world of professional event photography.

2. Initial Contact

First impressions are important, unless you are the only photographer in town and you don't have to worry. If not, your competitors will create a better impression and will get the job. It probably makes sense to create your own positive impression right from the beginning.

WEB SITES

Your first opportunity to create a good impression typically comes when a potential client arrives at your web site. Clients today are increasingly savvy when it comes to finding photographers on the web. If you are skilled at maintaining a good site, you've got an excellent tool that will serve you 24/7/365.

Creating a good impression makes your job easier.

Your web site placement is important because most potential clients will browse only the first few pages of Internet search results. Few are likely to look at photographers listed on page 800.

It is critical that you use keywords in various parts of your web site, because that is how web spiders discover and rate your site. You should be sure to use these keywords in the body of the text as well as in the header section of the HTML code. Typical keywords might include: event photography, event photographer, event photos, event photographer in your hometown, hometown event photographer, hometown event photographs, your state event photographer, birthday photographer, birthday photos, birthday photographs, anniversary party photographer, sports photography, golf tournament photos, golf tournament photography, gala photographer, gala photography, dance photographer, ballroom photographer, retirement party photography, grand opening photographer, ribbon-cutting photographer, graduation photographer, etc.

See if you can work those same words into the text that accompanies the web site. For example: "I am a [insert your home town]-based photographer specializing in event photography in [insert your state]. I specialize in taking photographs of events, including birthday parties, anniversary parties, golf tournaments, and other events where a skilled event photographer is needed to ensure seamless coverage of your important affair. We would be interested in photographing your special day. Do you need a photographer for your gala? We do gala photography. We offer retirement party photography or will be glad to cover your grand opening as your special photographer. Planning a family reunion or celebrating an anniversary? We photograph all kinds of social events and gatherings. We also do business photography and sports photography and would like to cover your event. Event photography: That's what we do!"

Once they click on your web site, how long does it take to download? A carefully crafted web site that is quick to load and easy to navigate is pretty important. I've seen sites that are beautiful but very slow to load. I'm sure you've switched off sites after a few seconds have ticked by with nothing happening.

Because I have a fairly complex web site structure, featuring lots of stock photo pages, I keep my introductory page as simple as possible with links that open other pages. I designed and maintain my site in basic HTML, and though it is not as fancy as other sites, I keep it current. I run Xenu Link Sleuth every time I update my site to make sure that all of the links are working properly.

Jim's web site is totally different. Moving, high-quality images dance before your eyes accompanied by lively musical selections. When you visit the site, you are invited to look further, and the entire process is easy and quick. It is difficult not to be impressed when you arrive at the various sub-sites in his system. Everything comes together quickly and effectively.

We both study our web site statistics so we pretty much know the words used by clients to reach the site. Thus, if we start receiving a lot of inquiries

It is critical that you use keywords in various parts of your web site.

Capturing and Preserving Life's Special Occasions

JPG Photo Events Team
www.jpgphotoevents.com
703-281-5441

*Give someone you love a
gift of lasting memory.*

Events. Engagements. Weddings.
Individual. Family. Beauty. Business.

Your choice: Your Style, Your Place, Our Place.

Studio located just five minutes from Tysons' Corner.

for "afternoon tea photography" we are quick to add those words to our collection of keywords.

ADVERTISEMENTS

If you have advertisements in your local newspaper, send out flyers, post notices at various public locations, or feature your work anywhere that the public will see it, then that might be your first contact with a potential client. A good advertisement will direct people to your web site, your e-mail, or your telephone.

It goes without saying that you should only use your best images in your advertising. You *must* make sure you have model/property/guardian releases! Take the time to create a clean image that is clearly visible. Avoid crowding too many images. Fewer stunning images are better than many good images. Remember that newspapers will typically run your photographs at a lower resolution (you'll see lots of tiny dots in the photos). Finally, don't feel that you must use four-color printing; black & white images can be very effective, and two-color printing is a lot less expensive than four-color printing. If you can afford it, or if you are only going to print out some flyers or posters on your home printer, then include some color images.

E-MAIL

Your second chance to create a positive impression typically comes when you get an e-mail or telephone call from a client. This is one area where the JPG Photo Events Team excels. We usually get back to the client within a few hours of receiving an inquiry. Our replies are carefully crafted, short, and include one or more attachments. One important attachment is a sample portfolio tailored to include photographs of events that we have covered. So, if we are being asked to provide information about galas, we include a "book" designed to highlight our previous work on galas (we keep it updated) along with other samples of our work. If they request a preliminary bid, we have a blank bid document on file and can quickly fill in the numbers and submit a complete document within minutes.

Our e-mail is the first step toward establishing our reputation as someone they will trust when it comes time to select an event photographer. That's our goal. That's our program, and it usually works.

You should only use your best images in your advertising.

TELEPHONE

If you don't receive e-mail, you'll receive a telephone call asking about your services. Jim and I both have two phone systems—a cell phone and an office phone. If we are busy, we have recordings letting customers know how else to reach us and asking that they leave a recorded message. My message says "You've reached William B. Folsom Photography. I'm sorry I'm not available to take your call. If you wish, please leave me a message, and I'll get back to you as soon as possible. If you'd like, you can call me on my cell phone: 571-213-8696. Again that number is 571-213-8696. Thank you."

Whatever you do, please create a professional sounding recording. Don't have a cute voice saying, "Mommy isn't here so leave a message. {Giggle}." Let your family and friends know that you are trying to build up a business and that they can still leave a message despite the professional recording on your phone. Also, take the time to slowly list your cell phone number so potential clients don't have to dial back and listen to the same recording to get in touch with you.

If we answer the call, we pretty much follow an unwritten script where we discuss our photography, our prices, and then ask for a way that we can either meet the potential client or send them some materials via e-mail.

Despite some claims about reliability, it is likely that a call will be dropped, especially when driving. I let clients know up front that I'm driving and may lose the call. I promise to call them back immediately if the call is dropped, and because my cell phone automatically captures the number of the last caller, that is not a problem. Static and poor sound, unfortunately, can sometimes be a problem.

I let clients know up front that I'm driving and may lose the call.

ON-SITE VISITS

Most of the photographers I've come to know over the years are more comfortable in blue jeans, flannel shirts, and sneakers or boots than in white button-down shirts, "power" ties, gray flannel suits, and shoes (or fashionable dresses and high heels). Many of us might not shave every day or bother to put on makeup. That's because we are somewhat of a special breed of artist that is up before sunrise to start photographing mist rising off a lake when the sun's first rays start to appear. While most of the world is still asleep or commuting to work, we are out photographing something visually exciting in cold, wet, and muddy conditions. That's the nature of many photographers.

Unfortunately, the rest of the world doesn't appreciate your sacrifices in the name of art if you show up for a presentation in a corporate boardroom wearing muddy boots, dirty blue jeans, and a torn tee shirt and smelling like pond scum. "Who cares? I am an artist, and all they should be concerned about is the quality of my work." Right! You show up with a two-day growth of beard, red-eyed, and drowsy after spending the night in a swamp photographing owls and tracking mud into their boardroom, and you expect them to hire you to photograph their annual charity gala? Good luck.

Fortunately, the world *does* understand that artists tend to be a little different, so a ponytail and beard might be accepted along with small studs in your ears or "artistic" clothing. If Jim and I come in to the same boardroom, we'll be clean-shaven with a conservative haircut and either dressed in suits, a blue blazer, or in our black outfit with logos on them and will address our clients on the same level.

Now, that doesn't mean *we* get the job. Heck, *you* might get the job instead! But, if we get the job they will pay us considerably more than they would pay you; you'll likely get the job because they'll expect you to do the job for less.

ALL THAT GLITTERS · · ·

Mangan Jewelers
6649 Old Dominion Drive
McLean, Virginia 22101
703-821-3344
manganjewelers.com

FACING PAGE—Use a prior job to help you book the next job.

On the other hand, there is an old adage in photography that says "never outdress the guests at the event." It's sound advice.

BUSINESS CARDS

A lot of photographers like to include samples of their images on the front of their business card. Our best advice is to print the photograph (just one) on the *back* of the card and keep the front of the card as clean as possible. Use simple, clear, bold fonts. Provide only key information: your name, address, phone numbers, fax number, e-mail address, and web site. Use the largest fonts you can since some of your clients may have trouble reading tiny print.

SUPPORT INFORMATION

I can sit down with a photographer I barely know and talk about photographing a river using a tripod and a very slow shutter speed to record the water's movement, and he or she will immediately understand and visualize what I'm taking about. Most people, however, don't really understand (nor really care about) the art behind the camera. They just want to know what you will charge (usually the first question) and what you will provide.

It is up to us to provide clients with samples of our work. That's logical.

Knowing that few people have the ability to visualize, it is up to us to provide clients with samples of our work. That's logical. Supporting documentation and photographs are another link in the process of winning a new client.

Jim and I recently finished a jewelry shot for a client, which appeared as an advertisement in a major publication in our area. So, we had quite a few images laying around that we could not use, except to promote our work. I stopped in another jewelry store to have some batteries installed into some watches. While I was waiting for the batteries to be installed I started talking to the owner about our recent work with jewelry. One thing led to another, and soon the owner asked if I could show her a sample of the advertisement. She also gave me a local wedding planning guide in which her advertisement was listed: it featured only text and was surrounded by ads featuring jewels or models wearing jewels. I went home and produced a 3x2-inch layout using the exact same wording that she used in her advertisement, but I included one of our model shots. I also ran a larger print so she could easily see the jewelry and told her that we would provide her with a variety of different sizes if she needed something for display. Finally, we attached a discount coupon using her store's name that she could give away to any newly engaged couple that purchased their engagement and/or wedding rings from her store. All this took less than a few minutes of my time using Adobe Photoshop and the existing images from our early shoot. Next time I visited her, I had everything ready to show her: no guessing, there it was. It all made sense to her the second she realized I had substituted her store's name and information in the sample ad. Can you answer the question: Will we get the client's business?

We've already discussed the importance of having a nice, clean, and impressive portfolio. No you don't have to have your portfolio bound in Corinthian leather, but it does have to be neat and clean (no coffee or ketchup

stains). Make sure the images are reasonably fresh (it doesn't help to have faded photographs taken twenty years ago).

ESTABLISHING YOUR QUOTE

In the final analysis, it is always about the money, so the quote you present to a potential customer as well as the way you present it will make the difference. Here are a few "rules" to consider when developing a quote that will help determine whether or not you get—or take—the job.

- *Understand your worth.* You have a great deal invested in learning your skill. You are, or are aspiring to be, a professional. So you need to examine the quality of your work, your experience, and the cost of equipping and running your business. This all adds up to an hourly or event rate that will support your experience and operational costs.
- *Understand the market.* Each geographical area has a different profile in terms of what a potential customer will be willing to pay. There are many factors involved in developing the market price, but the best way to determine the market price is to establish a range of what others are charging for similar services. If you can determine what a photographer may charge, then go to the web site and see how you stack up.
- *Price it right.* When you are starting, no matter how good you may be, do not price yourself at the top of the market. Those who operate there have spent twenty or more years learning the skills and building the reputation. So price yourself in the middle of the pack. The lower side usually tends to be bargain producers who operate at a volume much higher than you will be able to generate.
- *Prepare the proposal.* You should spell out exactly what you will do in terms of coverage, how long you will spend doing the event, and what and when you will deliver. The time and delivery aspects of the event are objective elements of the proposal. Allow yourself enough time to complete the postproduction and package the deliverables. Put all this in a contract outlining the events that both the client and you will sign.
- *Deliver the proposal.* Electronic delivery is perhaps the best, but it may be appropriate for some events to meet with the client to discuss specific requirements. Often the setting for the event can be addressed in your contact. It can also specify the background used by the event planner at the event venue.
- *Follow up.* After a reasonable period of time has passed, follow up to see if there are any questions. The client probably has asked for several quotes, and your follow-up may make the difference. See the discussion below.

FOLLOW-UP

Despite everything we do to make our initial impressions favorable, we know that we can't sit back and wait. Jim has a saying that we "must touch each client five times" before we have a confirmed customer.

When starting out, do not price yourself at the top of the market.

The first time you "touched" a client was when he/she visited your web site or saw an advertisement. The second time was when they called you. The third time was during the site visit. The fourth time? Once you get home, pull together a digital portfolio of those items you discussed at the meeting and send the prospective client a thank-you e-mail briefly summarizing the items you discussed and attaching a sample portfolio of your work in that area.

A week or two after our initial contact, we make it a point to touch base with the client to see if there is anything else we need to do on their behalf. That is our fifth chance to "touch" the client. In many cases the client is comparing competing offers and might be waiting for another bid to come in. In some cases they have to pass the bid documents on to higher authorities for approval. In a few cases, however, they may have unanswered questions about your, or your competitor's, bid. In that case, a follow-up call can actually help you create a stronger impression—you'll come across as someone who cares enough to help. Does it always work? No. Sometimes decisions are made on price alone and the lowest bidder gets the job. Sometimes a member of the family gets the job, or a friend, or whatever. You'll never know, so don't worry. You did your job.

It took us several tries, including this complimentary shot, before we landed this account as a client.

3. Equipment Requirements

Many beginners start their career with a basic camera, one or two lenses, and a flash unit. Later, as they accept more assignments and begin to encounter difficult lighting conditions, they will gradually accumulate more and, hopefully, better equipment. We keep camera bags that hold equipment designed for small, medium, or large events packed and ready for us to grab on the way out the door.

This is a typical small event photo.

Before we discuss what we take along, it is best to discuss how we decide. If possible, visit the venue where the event will be held. As you complete more and more assignments, you will develop a database of specifics about a venue. Keep notes about each venue. Know who the venue event manager is, what they expect of you, and what you can and cannot do. Most importantly, make sure you have a backup plan. In this business one thing is certain: when something fails, it fails at the most critical time.

SMALL EVENTS

Our "small event" kit is designed to help us deal with the various contingencies we'll encounter in a small event (typically five to twenty-five people). These events might include a baptism, a small birthday party, a family gathering, anniversary party, or the opening of a small business.

We head out the door with the following:

- two main digital cameras
- two backup digital cameras
- a wide-angle lens
- a moderate telephoto
- a zoom telephoto
- two flash units
- two brackets
- two power packs
- two rechargeable battery packs
- two gray/white/black cards
- two tripods (stored in the car)
- a stepladder

Know who the venue event manager is and what they expect of you.

Typically we each carry a slightly different lens; Jim prefers an extreme wide-angle lens and I use a moderate zoom telephoto (35–70mm). This gives us the flexibility to handle just about anything that comes our way.

MEDIUM EVENTS

We both use fairly large Tamarac camera cases on wheels. They serve as our "office" at medium-sized events (twenty-five to one hundred and fifty guests). Typical events include golf tournaments, political events, award ceremonies, ribbon cuttings, large parties, and other similar events. There may be an outdoor component as well as an indoor setting that we have to deal with. Our camera bags typically contain the following:

- two main FX or DX digital cameras
- two backup digital cameras
- two wide-angle lenses
- two moderate wide-angle lenses
- two zoom telephotos

- two primary flash units
- two backup flash units
- two handheld light meters
- two brackets (e.g., Stroboframes)
- three or four power packs
- four rechargeable battery packs
- two gray/white/black cards
- two tripods (stored in the car)
- a stepladder

Flash units will be needed to provide fill flash for any outdoor activities that will be captured, and a fully charged battery pack will allow us to effectively deal with any lighting conditions we may encounter for up to four hundred images. The activities will typically move indoors where the second battery pack will replace the first one, and it too will provide light for another four hundred images. The two battery packs ensure that we will have between five hundred and one thousand deliverable images at the end of a shoot.

This is a typical medium-sized event.

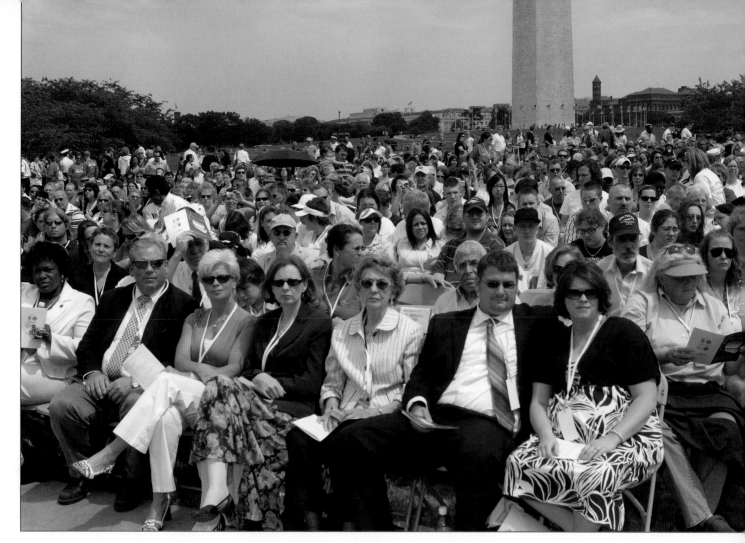

This is a typical large, outdoor event.

LARGE EVENTS

Large galas, formal dinners, big fund-raisers, sizeable public events, etc., typically attract anywhere from one hundred and fifty to five hundred guests and sometimes as many as one thousand plus individuals. Again, we need to anticipate both outdoor and indoor lighting conditions and have to be prepared for almost nonstop shooting from the time we arrive until our designated departure time.

We typically arrive with most of the equipment outlined previously for medium-sized events, but we also are able to deliver on-site studio photography and prints. This is true of golf tournaments and galas where we photograph the golfers on the course and the guests as they enter the ballroom. The photos of the golfers on the course are printed out and are waiting for them when they complete the game. Photographs at galas are usually quickly posed (less than a minute or two), and any prints are delivered in less than two minutes, giving the guests time to pay (or make a donation), and they are off. This requires us to set up a mini studio consisting of the following:

- a primary camera on a tripod (the others are used to capture the event)
- two tripod-mounted flash units (triggered by a remote signal)
- a black backdrop (two stands and a pole)
- a tether cord from the camera to a laptop

- a laptop featuring Capture One Pro software
- a printer hooked up to the computer able to produce a 5x7-inch print in seconds, with the name of the event or sponsor on the photograph

ABOVE—This is a typical large, indoor event.
FACING PAGE—We try to take a head-and-shoulders shot as well as a full-length shot that shows off the lady's attire.

Through trial and error, we've found that guests at a gala will pay a $10 fee with a $20 bill and will expect change but will gladly donate $20 for their photographs if no fee is identified. Thus, we usually encourage the hosts to ask for a donation rather than a $10 fee.

As part of our package of services we try to show the host that having a mini studio photograph their guests as they enter is good business—even for charity events. It takes an hour to an hour and a half to set up the studio. This mini studio is fairly expensive to set up and operate, and we usually charge somewhere between $2,000 and $3,000 to run the studio. This is in addition to what we charge to photograph the event. If we can photograph fifty couples donating an average of $20 each, we've generated $1,000 in income. If we can photograph seventy-five couples, we've covered half our expenses. We usually end up photographing around sixty couples during the course of an evening; that generates $1,200 in income. This is where it is useful for a sponsor to step in: for a payment of anywhere from $800 to $1,800 the sponsor can have his company name imprinted on each and every photograph handed out that evening.

The workflow during a typical gala includes photographing twenty couples as they enter the ballroom during the first hour. We need to pose, photograph, and print out photographs of twenty couples every three minutes. This is where reliable, tested, high-speed techniques and equipment are a must!

While all of the guests are enjoying canapés and cocktails, we usually photograph fifteen couples and their friends. During the dinner we'll have the Master of Ceremonies (MC) announce that the photographers are waiting in the lobby if anyone has not yet had their photograph taken. That usually results in guests at a table deciding to have their pictures taken together, and we can expect to photograph fifteen groups after dinner. There are usually a few people who come over toward the end of the evening and ask us to photograph them and their friends before they start to leave for home.

Our staffing for the mini studio includes assigning three persons to this operation: someone (preferably a female) who will quickly pose each couple or group, the photographer who will get them to smile at the camera and who

Trio entering a reception.

keeps a lookout for the inevitable blink, and finally, the person who handles the image as it arrives on the computer and then chooses the best image to be printed. While the image is being printed, money is collected and the next couple steps forward to be posed.

While one of us is photographing couples in the mini studio, the other is taking photographs of the guests greeting each other, meeting new friends, chatting, heading into the dining room, and then posed at their tables. Quite often you will have thirty to fifty or more tables to photograph, and that is when the second photographer takes a hand in table photography. Then it's time to take photographs of the MC and the guest speakers, followed by entertainment and dancing. Next, we'll head back to the mini studio to complete the night's work. Once the appointed time for departure arrives we still have

about forty-five minutes left before we can pack up all our gear, load up our vehicles, and leave.

OTHER ESSENTIALS

In addition to our working equipment, we usually bring a supply of business cards and some large posters providing information about the mini studio (e.g., with a cash donation, you will receive a 5x7-inch photograph, prints are delivered on the spot, etc.). Finally, we may have a poster offering a free portrait session that we have donated as an auction or raffle item.

A quick shot of guests getting ready to head off to dinner.

4. Effective Planning and Execution

PREPARATIONS

Most of the time we arrive at our location an hour before we are scheduled to begin. That allows us ample time to find the location, locate a place to park, unload our gear (sometimes this requires two or more trips), find the designated location, and assemble our camera equipment. Although we checked everything as we packed or repacked our bags, we check and substitute as needed before the event begins.

Once our equipment is ready and has been tested, we'll make a quick sweep of the facility to find the best spots for taking pictures. We'll look for balconies, steps, unusual backgrounds, or places where we can pose people without blocking traffic, or capture that unique perspective.

The famous Willard Hotel in Washington, D.C.

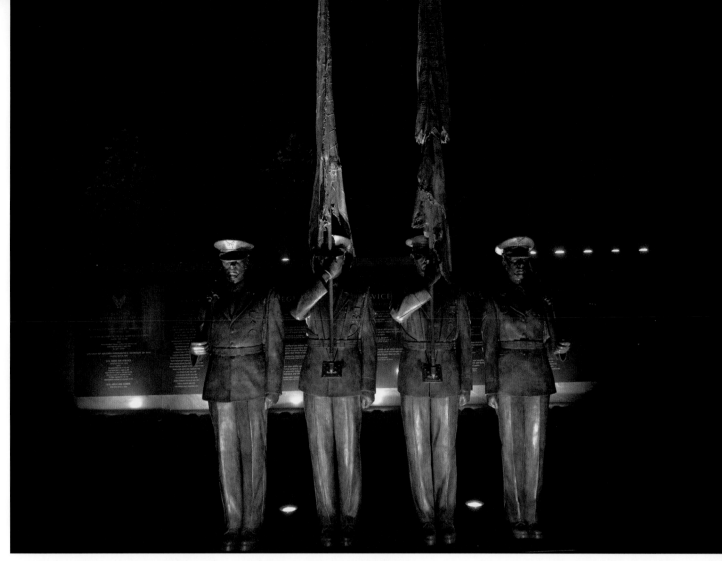

Photo of the U.S. Air Force Memorial, taken before sunrise on the day the event began.

PLANNING AND EXECUTION

Start by doing the standard event venue shots. Every wedding photographer delivers shots of the church. Not every event shooter captures something about the event venue and the surroundings. If the client paid for a top-of-the-line hotel, get some photos of the façade and the decorations. Photograph the parks and monuments nearby. In some cases, it may be the only memory some of the attendees have of the event surroundings. Get the foyer and the ballroom entry along with the event signage, if any. I recall a corporate client who told us that the difference between us and the other event photographers is that we placed the event in photographic context.

Then, we locate the person who hired us or the liaison assigned to work with us during the event. We then review our plan with that person. The following are some of the typical questions we'll ask:

- Do you have a written timeline of the event? Can we have a copy?
- Have you invited any special dignitaries that you want us to photograph?
- Will you be able to point out some of your senior officers so we can photograph them before the event gets underway?
- Are there any restrictions on flash use during any part of the ceremony?

- Do you have any groups you would like to have photographed (e.g., the committee who organized the event, special youth groups, awardees, etc.)?
- Will you be able to make announcements telling those groups where and when to meet us?
- Are there any *must-have* photographs we need to take?
- Can you give us a heads up before any major event? (This allows us to be in the right place at the right time.)

We also review our payment schedule and let the client know how we will deliver the final product.

If the liaison is well organized, he or she will have a carefully choreographed timeline for us to follow and frequently will assign someone to stay with us and target specific people or moments. Relaxed liaisons usually ask us to photograph the guests mingling and sitting at the tables and ask that we take photographs of the speakers. Either approach works well.

There are several events where advanced planning is necessary. In some cases, you should plan for a site visit before the event. These include a golf tournament where you should go out and drive the course (it beats getting lost during the tournament), weddings (you should visit the church and reception hall), and events where security requirements mandate that you arrive well in advance of the VIP. (The higher the rank, the earlier you'll need to show up and find out where you will or will not be allowed to photograph.) We'll discuss each of these scenarios briefly later in this chapter.

In some cases, you should plan for a site visit before the event.

SPECIAL CONSIDERATIONS

The following paragraphs summarize some of the special planning strategies that go into taking exceptional photographs at an array of different events.

Anniversaries. Some couple in your town is sure to be celebrating their fiftieth wedding anniversary in the next month. Hopefully the siblings will do a search for "anniversary photographer" and your name will come up. This is a great chance to be paid to photograph the couple with all their children and grandchildren in attendance. You must break each sibling's family down for a shot with mom and dad and possibly line up all the grandchildren. This is a great opportunity for indoor or outdoor group shots with plenty of print sales for you to fulfill.

THE "REAL POWER" BEHIND THE EVENT

Occasionally, you'll run into a situation where the person assigned to work with you will be told by a ranking individual to do something totally unplanned. If a ranking person overrides the liaison, it can be very difficult for you and the liaison. This is a situation in which tact is critical. You need to do what the "real boss" wants photographed rather than follow the liaison's plan. It's a tightrope walk, but hopefully you'll be able to meet everyone's requirements. Tip: If you work as a team, then one of you can follow the "real boss" around and the other can prepare to follow the liaison's instructions.

A fiftieth anniversary party.

There is not much preparation needed for anniversaries. You do need to find the right house and be there ahead of time to set up your equipment. You'll need to find out how many people will attend (ten? twenty? fifty?) so you can find a suitable spot inside the home or in the backyard where you can set up a minimum of two chairs or enough chairs for the mother and father to sit next to their daughters. Husbands and older sons typically stand behind their wives or mothers. Children can be seated in the grass in the foreground, and mothers should hold their babies. Take four or five shots in succession shouting out "Eyes wide open!" to avoid the inevitable blink.

If working indoors, be very careful not to knock something over when you set up, move, or break down your tripod, lights, backdrop poles and stands, or when you unplug any extension cords. If you have never considered business liability insurance, you'll want to look into it just after you've knocked over and smashed someone's prize collection of antique crystal (it would be best if you bought your liability policy before that happens).

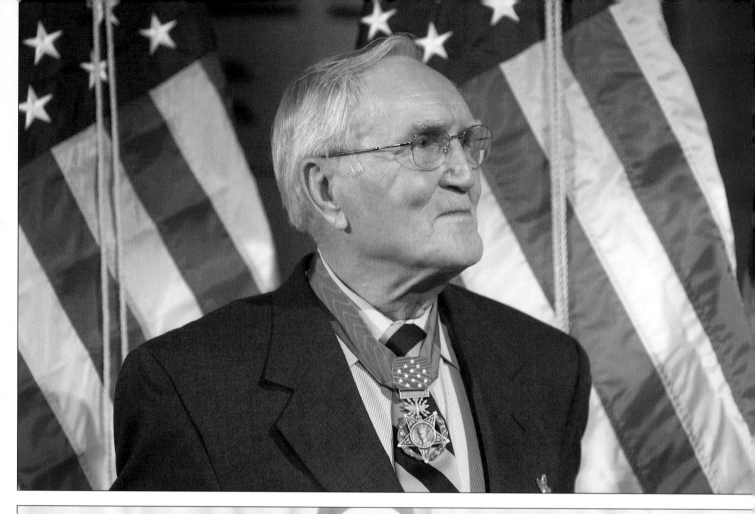

Award Ceremonies. You'll need to carefully review the timeline before the ceremonies begin so you can plan accordingly; will you photograph five people? ten? twenty? more? Where will they stand? Should you set up a black backdrop behind them or simply use whatever is available? Ask if you can speak to the MC. Ask if, after he presents the award, he will request that the recipients stop for a moment and face the camera. If they were awarded a plaque (especially one with a reflective surface) they should point the award at you,

but at an angle to avoid having your flash bounced back into the camera. Now, here is an important tip: some MCs will forget to ask the recipients to pose for the first two or three times. It is *your* responsibility to stop them and ask them to pose. Once you do it once or twice, the MC will usually take the lead and you'll finish the assignment with little or no trouble.

Bar and Bat Mitzvahs. These are carefully controlled religious ceremonies, not photo ops! You should ask the parents of the young boy or girl to walk you through the synagogue well before the religious service. Also ask if you can talk briefly with the rabbi. Most synagogues have written regulations stating what you can and cannot do. Don't violate those rules!

FACING PAGE—(TOP) Ceremony honoring Medal of Honor recipient. (BOTTOM) A typical award ceremony honoring an individual.
TOP—A proud mother with her son.
BOTTOM—A proud father with his son.

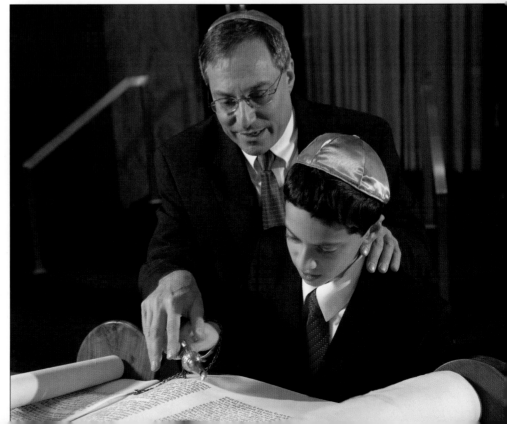

Typically you will be allowed quite a lot of time and a fair bit of freedom during the rehearsal before the actual Bar or Bat Mitzvah takes place (usually on a Saturday). A stepladder might be useful because it will allow you to photograph looking down at the young person reading from the Torah.

It is important that you take as many photographs as you can during the rehearsal, because you will not be given much latitude (if any) during the actual event that takes place a couple of days later.

Once the ceremonies are concluded, you'll have a few minutes to pose the family with the rabbi. Then you'll shift over to the facility where the kids will play games, have fun, eat, and enjoy themselves. Since you are photographing thirteen-year-olds, expect a lot of action!

You must also be prepared to capture a few events that take place at the head table just before and after the meal, including blessings over the bread and wine, and toasts, hugs, speeches, and congratulations.

Birthday Parties. All of us have attended birthday parties, so there is little that you don't already know. Photograph the birthday boy or girl blowing out the candles, opening gifts, and having fun. If the parents are willing, you might offer a few tips to make the experience a little more fun. For example, for one thirteen-year-old's birthday party we designed a red-carpeted walkway for the guests to enter. We rigged up a bank of flash units on either side of the walkway timed to fire as the kids walked down the aisle. The young girls loved it! The young boys (well, most of them) slinked off to link up with their buddies as fast as they could. We also had a large black background where we photographed groups of kids. At least here the boys also got into the action, clowning around with all their pals. It was a pretty exhausting night trying to keep up with them.

A SEAMLESS LOOK

Suggest that the children and parents wear the same clothing to the rehearsal and religious ceremony. You likely won't be able to take photos during the ceremony and will have only a short time to photograph the kids, proud parents, friends, and family after the event. When the subjects wear the same clothing to both the rehearsal and ceremony, there will be a seamless look in the photos.

The girls loved the "red carpet" treatment.

A good shot that would have been better if the floor was covered with the backdrop.

Business Mixers. I've been a photographer for the Greater McLean Chamber of Commerce in McLean, VA, for almost a decade, and I have photographed hundreds of chamber events, including breakfast meetings, luncheons, political events, business mixers, golf outings, and galas. We include all of these under the "business mixer" category, although several of them are also described elsewhere in this section.

My strategy for photographing all of these events is to arrive fifteen minutes early (only because I know the drill and the locations) and set up my equipment. I then check in with the president of the chamber and get my information about new members, special guests, or speakers. Once a featured

guest or speaker arrives, I take his or her photograph with the president of the chamber. That image is likely to be published. Once that is finished, I'll concentrate on member-to-member activities. I don't have to worry about getting names, because the members are well known to the president of the chamber, who will prepare the articles for the chamber's newsletter. I take a few shots during the meal, then make sure I photograph each and every speaker. I'll deliver my CD of the event the next day. Because I've done this for so many years, just about everyone knows me. At a majority of these meetings, I get a tip about someone who might need a photographer, if not an actual request to take photos.

I take a few shots during the meal, then photograph each and every speaker.

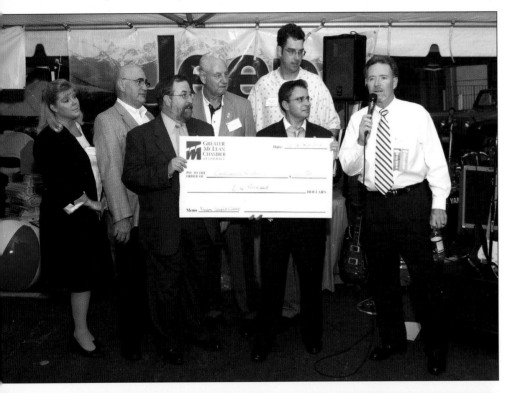

TOP—A typical scene at a business mixer.
BOTTOM—A political forum organized by the Greater McLean Chamber of Commerce.

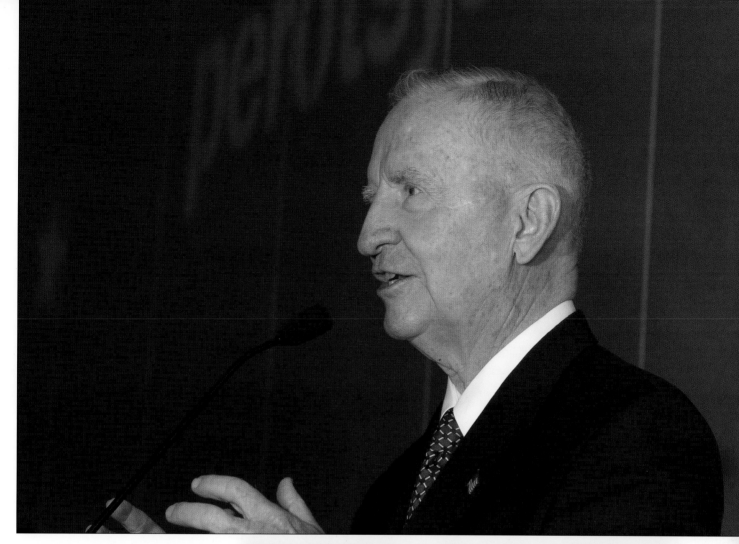

TOP—Ross Perot speaking at a corporate function.
BOTTOM—Typical foursome at a Washington, D.C. corporate event.

Corporate Functions. We classify corporate functions slightly apart from business mixers, in that I usually know everyone at chamber events but rarely know all the key executives, board members, and major stockholders at a corporate function.

This is an event where we definitely want to arrive early and huddle with the designated liaison to find out exactly what is going to happen and when, and to get guidance on exactly who we must photograph. We will check back repeatedly throughout the event to make sure that someone important has not arrived that we need to photograph.

Aside from the issues mentioned above, working a corporate function is simply a matter of photographing people without becoming a nuisance, while capturing attendees at their very best. A fair amount of practice is required to be able to capture those really great moments.

During these events there is generally a brief announcement made by the CEO recognizing different guests or outstanding employees. Make sure you are there to capture those moments, not off enjoying your third helping of shrimp!

County Fairs and Local Events. County fairs and other local events take place all over North America. Usually these are held at the local fairgrounds. You get to see lots of prize-winning animals, carefully groomed and ready to

We definitely want to arrive early and huddle with the liaison. . . .

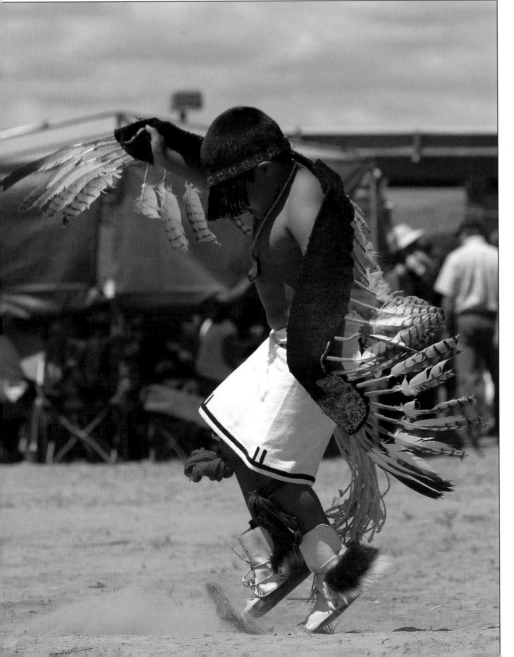

A Native American arts and crafts show in New Mexico.

LEFT—Participants at a Slavic festival. RIGHT—An attractive lady in her native costume at a Slavic festival.

be photographed. You'll also find prize-winning vegetables and samples of cooking (pies, breads, jams, cakes, etc.) with the proud winners there to talk about their specialties. Ask if you can take their picture. Go ahead, do it! You might end up with a client! Get photos of the children riding pigs or leading their pets on parade. You'll have lots of vendors who might enjoy a picture of themselves at work. Who knows, a couple of years after you've started you could operate your own booth at a county fair where people come to you for special, introductory photos!

Festivals. There is almost always a festival going on someplace—a peach festival, strawberry festival, pumpkin festival, arts festival, Polish-American festival, fall festival, etc. These are usually held at a local park, or sometimes a downtown street is closed off. Wherever you find funnel cakes, merry-go-rounds, displays of art, cooking, or animals, it qualifies as an opportunity for you to wander around taking photographs. Festivals are a wonderful opportunity for you to take someone's picture and then offer to send him or her a complimentary 4x6- or 5x7-inch print. If you take a photograph of one hundred subjects and send each of them a print, you might end up with one to

Bidder Number 742

MESTRETCH
preserving Families to

2007
Wine Tasting
and
Silent Auction

September 28, 2007
7:00-10:00 pm
Today Building, McLean, Virginia

FACING PAGE—We generally have a complimentary ad in the event program. ABOVE—A typical fund-raising event photo of the honorees.

ten new customers who are willing to pay for your normal professional services. It could be a product shot (the best baked pie, an award-winning cow, someone's handcrafted jewelry) or a head shot. The bottom line is, this is a great time to gain exposure in the community.

Fund-Raisers. Fund-raisers and galas frequently overlap, but fund-raisers can sometimes be a little more fun, depending on the theme for the evening. This is an opportunity for you to meet and photograph some of your wealthier neighbors and to introduce these individuals to your work.

As part of our package of services we'll explore getting a free full- or half-page advertisement in the program in exchange for some of our coverage. We also offer a complimentary gift for a raffle, silent auction, or door prize—typically a free headshot or a glamour shot at our studio.

After that, the event flows pretty much like most other social events. You'll find people arriving, registering, and picking up their name tags or bid documents, wandering around to look at special display items, chatting with their friends, and socializing. There is usually a break when the CEO stands up and talks about their goals and funding requirements, and this is usually followed by dinner and/or dancing.

Galas. Galas present another moneymaking opportunity. You can get paid to photograph the event or volunteer to photograph the event (especially for charity events) in exchange for free advertising. You can donate raffle or door prizes or auction items featuring a free portrait session. You can work with

the organizers to sponsor a mini studio where guests are offered the chance to have their photographs taken in exchange for a donation which can be used to offset your operational costs. Running the mini studio gives you the chance to convince people that you are a gifted photographer. If you can take a de-

Couple photos are a hit at events when the participants are dressed in their best attire.

cent photograph of them in under a minute, imagine the results if they come to you for a portrait session lasting an hour!

When working at a gala, photograph the guests in such a way that they look great. Most men will be dressed in tuxedos. The women will have spent a lot of time and money getting their hair and nails fixed and will appear in a new dress with lots of jewelry. Time the photo to make the subject look good, even if you ask them to pose briefly. Maintain a positive chatter to help them feel relaxed. Don't photograph them eating. Wait for coffee and dessert, and then ask them if you can photograph everyone at the table. You may need to have some guests stand up behind the center of your photograph. Take two photos to make sure someone isn't blinking.

When a guest asks you how they can see the evening's photographs or order prints, direct them to your web site where your images will be displayed (as quickly as possible). Hopefully you will have a fulfillment center that will have your images up and ready for sale inside of a day or two. You can also give the person a business card and suggest they get in touch with you directly if they have any questions or problems. You can also refer them to your colleague out at the mini studio.

Golf Tournaments. Golf tournaments are another way to show businessmen and women the depth of your photographic work. The first part of the day starts when everyone jumps into a golf cart and heads off for the links.

Be sure to capture the action.

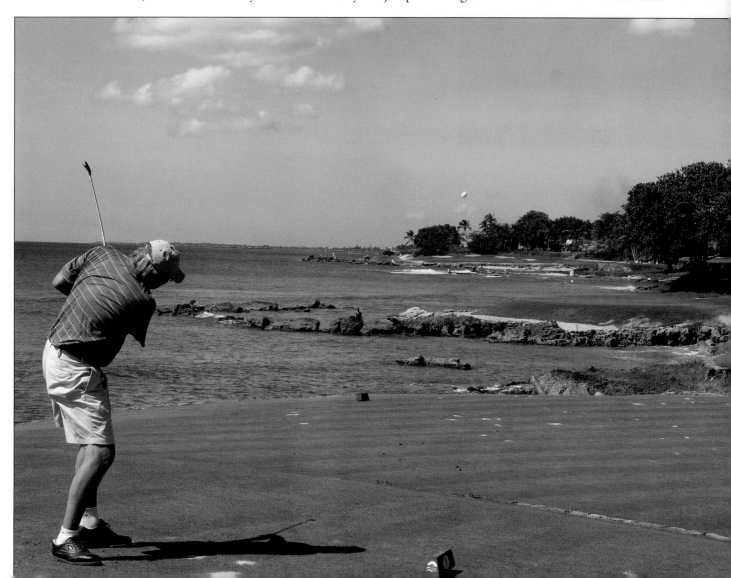

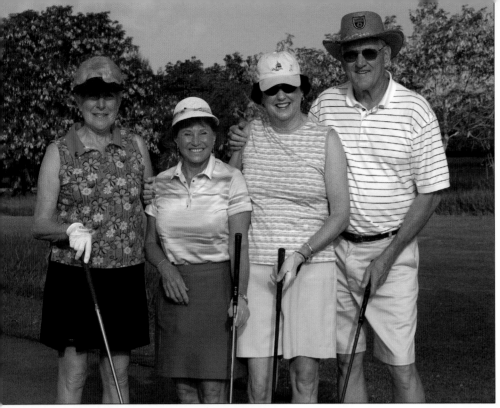

Make sure you have your own golf cart (ask the organizer to set one aside for you and your associates), and if at all possible, have a volunteer drive you around the course. You typically must cover eighteen holes in order to capture each group of golfers (usually four to a group). If one of your colleagues starts off at the first hole and you start off at the last hole, you should be able to photograph every group before linking up in the middle of the course. You then head back to the clubhouse where you have a computer and printer setup waiting. You review the images (take two photographs of each group to try to eliminate blinking) and begin printing four prints for each group. Within an hour or so, you should have a photograph of each and every player. If you missed a group, or if there were problems with lighting or focus, you hop back on the golf course and find the players and take another series of shots.

Like any sport, you have to know something about the game to appreciate what is important. If you have ever watched a golf tournament on TV you noticed one thing for sure: before a player makes a shot, there is someone holding up a *Quiet* sign in front of the gallery and asking for quiet. *Quiet* also applies to mirror slap. Even that can distract players. So if you are doing action shots around the course, do so where you will not distract the players.

The more players, the longer the tournament event will take. On the average, a best-ball tournament will require five hours to complete. Normally there will be two foursomes on each of the eighteen holes except the four par

The more players, the longer the tournament event will take.

three holes. The par threes are shorter than the other fourteen holes, and the players will bunch up there. In all, there will be thirty-two foursomes, for a total of one hundred and twenty-eight golfers on the course.

Then, when all the teams start to head back to the clubhouse, you'll have all your photographs ready to be picked up. You can either sell them yourself or you can have a sponsor whose logo will appear on each photograph. Either way, you've been paid for a good part of your day.

The last portion of the event is the social hour after the tournament where guests unwind, have a few drinks, and mingle, then dinner is served. After dinner, awards are typically given for the longest drive, team with the lowest/highest scores, etc. It's a great time with lots of laughs. Just make sure you've talked to the MC about having the guests face you after they pick up their award. If not, stop them and say, "Face this way and I'll take a photo of you guys!"

Holiday Parties. There are many national, state, regional, and local holiday parties that offer you the chance to take photographs. Many corporations sponsor a holiday party during the month of December. This is their opportunity to thank their employees, and it gives them a reason to entertain their best customers. Be ready to offer your services as a holiday party photographer. Some holidays have evolved into fun events while others remain solemn events that feature speeches, memorial services, and wreath-laying ceremonies. Some events have become more of a reason to hold a sale than to celebrate the real purpose of the holiday; even those, however, do offer you some opportunities to take photographs on assignment.

The holiday season always includes office parties.

A beautiful smile captures the spirit of the evening at a corporate inaugural event.

Inaugural Events. In Washington, D.C. we think of inaugural events in terms of Presidential Inaugurations with all of the pageantry and festivities associated with a major change of administration. It is pretty exhausting work with a lot of restrictions imposed by the U.S. Secret Service, U.S. Park Police, Capitol Police, and Metropolitan Police.

However, inaugural events can also include the commencement of a new service, such as the inauguration of an airline out of a local airport, the roll-out of a new model automobile, or anything else that is new to the community. These are also great chances to increase your sales if you are aggressive in pursuing these leads. Since the business community introduces most new products, it makes sense for you to stay involved with your local Chamber of Commerce where you will likely hear of new developments before they become public.

For someone living in a small town, a great opportunity may present itself in the form of the opening of a new library or shopping mall or a new store in the mall. No matter what, it represents an important time for the persons involved in that project, a time that they want recorded. This is also a time when they are more likely to spend a bit more money on photography than for just another Presidents' Day sale!

Military Ceremonies. Many communities have their own Active Duty, Reserve, or National Guard units, and some of you likely live near a military base.

Inaugural events include the commencement of a new service.

Entry and Access is Restricted. Most military bases do not have open access, so you will need to get a visitor's pass to enter the base or facility. In some cases, you may be required to have an escort to remain with you at all times during the ceremony.

Military Photographer. With the exception of a military wedding, there is a military photographer assigned to cover military events. When the military photographer is present, he or she is the principal photographer. Be sure to find that person and introduce yourself.

The Event Will Start On Time. Generally, the only exceptions are if an event is interrupted by a national disaster or the senior official has been delayed. Be sure to get to the event site well ahead of the start time.

Military Events Follow Protocol. In the military there is a set sequence or protocol for every sort of event. For many, there is a published program listing the sequence. If you are not familiar with the protocols, invest in a copy of the *The Officer's Guide* or *The Noncommissioned Officer Guide*. Both are available in bookstores.

A military awards ceremony.

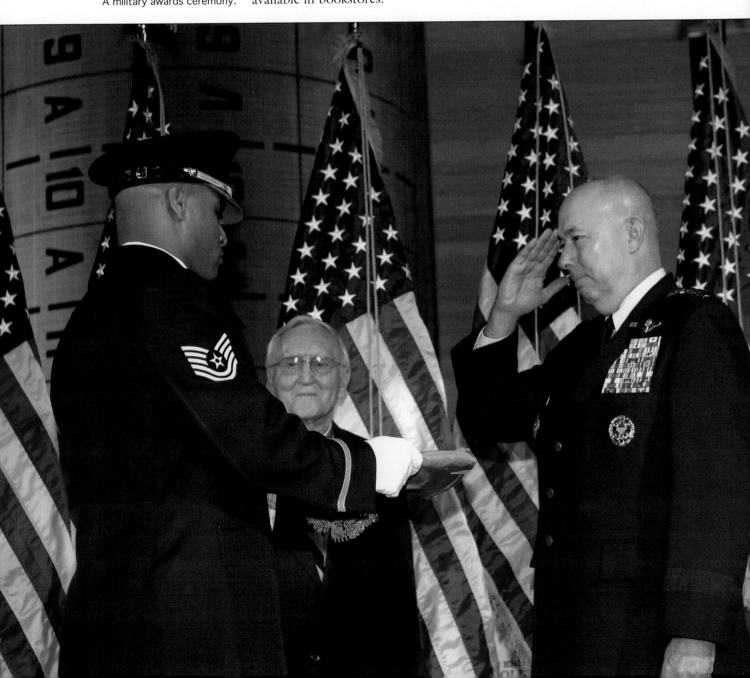

Commonly photographed military events include:

- *Weddings.* Military weddings are like all others in that the couple exchanges vows and are blessed with clergy and guests. The difference normally is in the exit from the church or chapel. Many of the grooms will have a number of ushers attired in dress uniform and bearing a sword as the bride and groom pass through an arch.

- *Awards and Promotions.* Awards and promotions are normally held inside in a large meeting room. The senior official and the family of the person being promoted join the awardees or person being promoted. As the ceremony begins, the senior person will say some words about the awardees or promoted person, citing accomplishments and their career progression. There will be a person who will read the order for the award or promotion aloud, then the new rank is normally pinned on the recipient's uniform by both the senior official and the spouse or family member of the person being promoted. For an award, the senior official pins on the ribbon. Following the "pinning," the awardees or promoted person will say some words. If the spouse is a female, there may be a presentation of flowers for her as well; the females' spouses usually just get an embrace or

FACING PAGE—Always check in with the military events coordinator.
BELOW—A U.S. Marine Corps memorial service.

handshake. Some sort of celebration normally follows the event. Photo opportunities exist as the awardee or promoted person mingles with the guests and accepts congratulations.

- *Retirements.* Some retirement ceremonies are held on a parade field. When the ceremony is held outside, it will include the reading of the retirement order, an award for service of the individual, and the pass in review of the honor guard. It is great pageantry and offers some great photo opportunities. The retiree normally selects a song or two that will be played by the military band at the conclusion of the ceremony.

- *Changes of Command.* Normally held outside or in a large gymnasium, the ceremony includes the senior commanding officer as well as the incoming and outgoing commanders. The majority of the event is about the outgoing commander. Again the orders regarding the assumption of command are read, then the command symbol or colors (flag) is exchanged. Following the passing of command, a pass in review is conducted, and the outgoing and incoming commanders review the formation. Following the ceremony, the outgoing commander departs and an incoming commander will host a reception.

A military retirement ceremony.

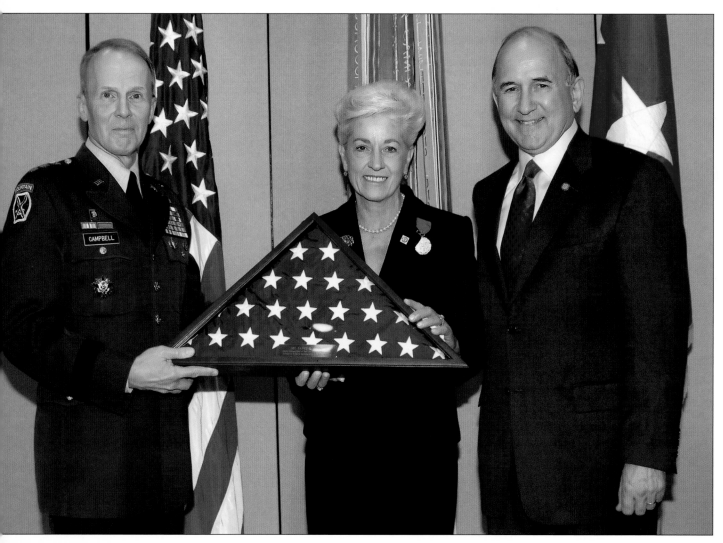

Memorial Day parade in Washington, D.C.

Parades. There are several times each year when parades take place, with the Fourth of July being the most obvious. There are many others, however, such as the St. Patrick's Day and Easter parades, as well as many local parades where an opportunity exists for you to photograph either a key individual or possibly a company's float. This is certainly not a major source of revenue, but we've photographed political officials in parades, and it is a good way of gaining exposure. Take photographs of kids along the route and give the parents your business card; you might end up with a print sale and maybe a portrait sitting. I am usually asked to photograph community leaders at these events.

The Greater McLean Chamber of Commerce in McLean, VA, sponsors an annual Rein Dog Parade where dogs are dressed up to look like reindeer, Santa, elves, etc. The owners then parade past judges who award prizes for the best-dressed dogs. It is one of the most popular events of the year, attracting hundreds of dog owners and their families and frequently local television coverage. As the chamber photographer, I have photographed this event for years; when the photographer who traditionally took photos of dogs and family members sitting next to Santa retired, guess who picked up the job?

Celebrities gather around an old fire truck following the annual Rein Dog parade. About sixty people paid to have their picture taken as well!

Political Events. Photographing political events can help you expand your base of clients, but you need to tread carefully. If you exclusively photograph one political party, you may lose clients in the other party. It is financially advantageous to remain neutral and photograph any and all political parties. However, if one candidate pays and the other doesn't, go with the paying job.

You can consider volunteering your services until you can prove that you are a really good photographer. It may take a couple of years, but eventually the party's leadership will recognize your talents and may ask you to photograph candidates entering the political arena. That allows you to bill the candidate's political organization for your services, which each candidate must have—you've seen the images, the candidate with their sleeves rolled up talking to policemen, firemen, the elderly, and parents of school-aged children. Someone has to take these images, why not you?

It's been my experience that politicians truly recognize and value the importance of photography. If you take exceptionally good photographs of them and mail them complimentary prints, they may contact you to provide paid coverage at some future event.

Product Releases. Every year companies like to roll out their latest product model. Perhaps it is a new automobile, or maybe a new blend of coffee or a new line of fall fashions. It really doesn't matter what the product is, it is the event that counts, and if you are aggressive (and maybe a bit lucky), you'll be hired to photograph the unveiling of that new product.

One event we photographed was the introduction of the new line of Aston Martin vehicles by the dealership in Tysons Corner, VA. It was a fun, relaxed event with lots of fine food, plenty of drinks, and fine cigars, plus lots of beautiful cars and women. We photographed it all.

U.S. Congressman Tom Davis with a constituent.

We made the vehicle stand out at the Aston Martin dealership in Tysons Corner, VA.

Before we photographed the Aston Martin assignment we visited the dealership and spoke to the manager. We asked that one of their convertibles be parked near the front of the dealership just below the Aston Martin sign and logo. Unfortunately, when we arrived on the day of the shoot the car was there, but parked in the wrong direction (we wanted to photograph people sitting behind the wheel with the logo in the background). It was too late to change so we simply had to come up with a different strategy. At least the manager knew what our plan was and why we wanted it that way, but the powers that be decided it would be parked facing in a different direction. The moral of the story is, plan ahead, but expect the unexpected.

Retirement Parties. Somebody is going to retire in your town or city—today, tomorrow, and/or the next day. Can you figure out how to photograph these events? Once you do, you could have yourself guaranteed work for the rest of your life. Retirement parties take place during lunch or dinner and usually at a local restaurant. Get to know the restaurant owners. Ask them

BRAND RECOGNITION

When doing a product rollout, make sure you keep the product and/or the company's name in as many shots as possible. You can't always do every shot that way, but do your best to include the company name, logo, product, or management or sales team in every image. The client will also want photographs of their customers having a great time; if you can catch the clients having a good time with the company's product, that will be ideal.

to give you a "heads-up" when someone books a special room in the back. Contact that person and ask if you can photograph their retirement party. Initially you may have to do it for free or at a low price until you can create a decent portfolio. Once you've proven yourself, you can increase your prices.

The scenario is generally the same: the retiree sits at the head table with his wife and boss and some senior members of the organization. Speeches are given. He/she is given a gold watch for all his/her years of service and it's over, except for a few last group photographs with family members and colleagues. Each group shot represents the sale of a couple of prints. You'll make money on the assignment, on print sales, or on both. Think about it.

Ribbon Cuttings. There is bound to be a new store or restaurant opening up in your town. This is a great opportunity to take photographs. One trick is to offer to take photographs and to deliver them with a write-up to

A standard retirement party shot with a farewell gift.

your local newspaper (they may have their own staff). Keep your eyes open for new sites and get in touch with the owner as soon as possible. Sometimes this works and sometimes not. You won't know unless you try.

Rodeos. Those of you who live in the western states can make money at rodeos. No matter the venue, all rodeos have three things in common: lots of

TOP—A ribbon-cutting ceremony at a new restaurant. The picture later appeared in a Chamber of Commerce newsletter about the event.
BOTTOM—Rodeos give you a chance to photograph young and old alike.

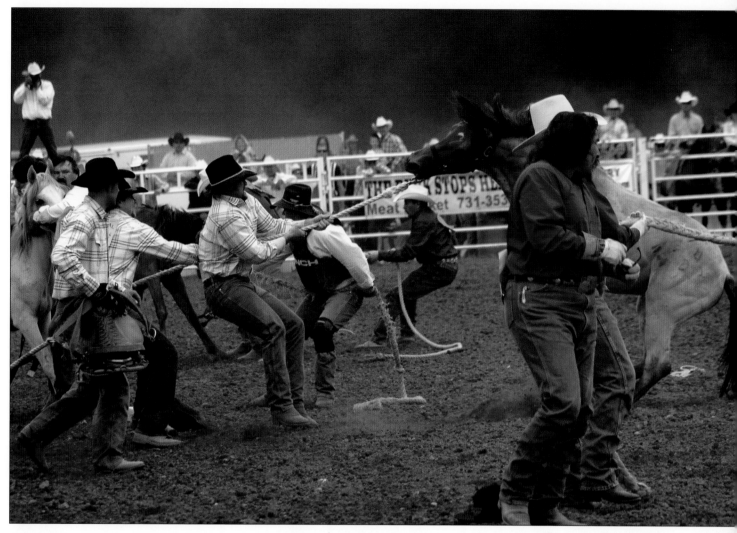

Rodeos offer great action and lots of color.

fun, lots of action, and lots of people! Check in with the rodeo organizers and ask if they could use some photographs. If you phrase it properly, you might end up with a paying job; if not, at least you'll get free admittance. Take photographs of everything, including the riders, and take down names. Perhaps you already know many of the participants; if so, send them a complimentary photo. Next year, they'll remember you. Now you can ask for a modest sum for a photo or invite them to your studio (or go out to their ranch) for a formal portrait session.

Sporting Events. Sports photography is somewhat of a unique branch of photography, just as wedding photography is a unique aspect of photography. Sports photography can be very big business for those who really follow sports: think of football, golf, and car racing—all command excellence in photography, and those who can provide it are well rewarded. However, you can also see sporting events as just another venue for you to practice your craft, expand your contacts, and get your name known. In this venue, Little League games, soccer matches, lacrosse, or other team or individual sporting events can afford you a great opportunity. So, get familiar with the various games played in your part of the world. Remember, a youngster winning his first

FACING PAGE—(TOP) A baseball game affords you the chance to take a lot of great shots. (BOTTOM) A girls' soccer match will give you great action shots. ABOVE—President George W. Bush speaking at the U.S. Air Force Memorial.

prize is just as proud as an Olympic athlete winning a gold medal. Both will appreciate a photograph, and proud moms and dads will become instant, and hopefully future, customers once they get to know you. Who knows? One day that young girl might become an Olympic gymnast and that young boy an Olympic swimmer, and you might be invited along to take their photographs.

VIP Events. In Washington, D.C., a VIP event typically involves a certain degree of security. Security arrangements can range from extreme (presidential involvement) to relatively relaxed (local police agencies). These events typically require you to arrive hours ahead of schedule, to clear security and also to allow you to find and save your spot; if you plan on arriving an hour before an event, you'll find all the best vantage points gone, and you'll be lucky if you are allowed into the event. Again, this depends on the level of security at the event.

As photographers who have covered presidential events at the White House and elsewhere, we would suggest that this is not the time for you to discuss your views of the president, his policies, or administration. Jokes are not appropriate and will not endear you to uniformed and undercover Secret Service agents covering the event. Give them your full cooperation. If they want their dogs to sniff out your camera gear, don't argue; you'll lose. If they tell you to stand over there, stand over there. Don't test them. They have their job

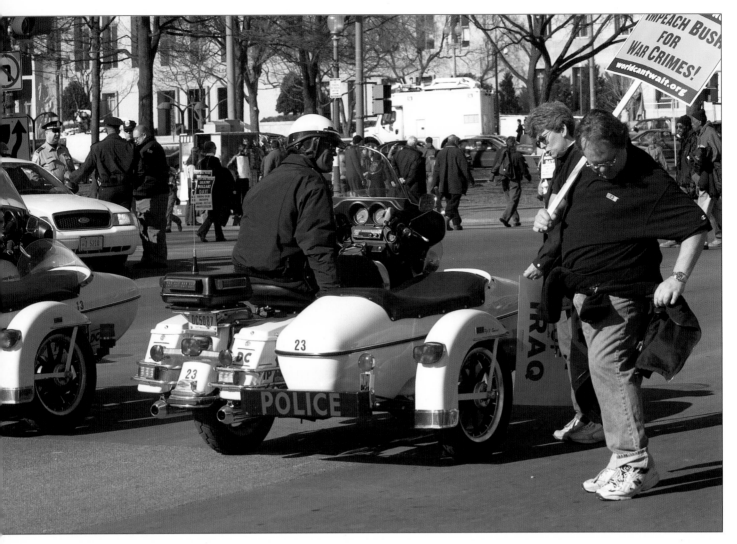

Security is always tight during VIP events in Washington, D.C.

to do and you have your job to do. Keep it strictly on a professional level, and don't be surprised if the rules change just before the president arrives.

In most other parts of the country, a VIP event usually involves either a governor, senator, or congressman attending an event or a movie or television star, a rap singer, or a sports hero. Many of these individuals have their own security detail that might involve one or two individuals. It never hurts to introduce yourself to them and let them know who you are, who you are working for, and to ask them if they have any special requests of you (e.g., don't get in his/her face with your flash while he or she is eating). These VIPs are used to dealing with the press and usually enjoy having their photographs taken, but they don't like being placed in unsafe situations. That is why their security detail is there.

5. A Winning Strategy

You'll face three types of clients in your photography career: those who have absolutely no idea what to ask for or what to expect; those who are organized and have a plan that they insist you follow; and finally those who are unable to define the outcome but want everything. Those who don't have a clue and those who are well organized are usually pretty easy to deal with. Those who have an unrealistic idea of what you will deliver can become very difficult to deal with. In order to have a winning strategy, you must sort it out and define the acceptable outcomes.

BEGIN BY TALKING

You should not simply accept an assignment without asking a few basic questions. Try to get a quick idea of what the client is looking for. If you get a

With proper planning and execution you'll quickly earn a good reputation for excellent work.

vague answer, that will be the first category client. If the individual has a massive list of what must be accomplished (this is particularly true of wedding photography), then you need to sit down with the client and carefully review everything on the list. You'll need to arrange for someone to assist you in identifying the key players in the event. You might even find it worthwhile to look over previous photographs to find out what the client liked and disliked about the other photographer's work.

The most difficult client to deal with has some concepts in his or her mind but can't clearly spell them out in advance; unfortunately, they can (and usually will) come forward with all kinds of demands (e.g., why didn't you take a group photo of the awards committee?) after the event when it's too late to change things. That is when you'll bear the full brunt of their anger for not doing your job (even though they never mentioned the "awards committee" during the event). These are likely to be the folks who will rant and rave, ask for a full refund, or threaten to take you to small claims court.

If you do not understand the customer's requirements, do not take the assignment! This sounds very simple, but it is an essential rule that many new professionals violate. You simply cannot deliver if you cannot specify what the client needs. If you proceed with the assignment, you are on track for a disaster and a degradation of your reputation.

HAVE A GOOD CONTRACT

Yes, we wrote about the importance of a good contract in chapter 2. This is where it will help you. You really need to be prepared for all of these people, and the best defense is a solid paper trail. Your signed contract is your most important tool. You should spell out what exactly you will and will not produce: You'll create sharp images in clear focus and properly balanced, color-corrected film or digital images delivered by such-and-such a date. You will take photographs of all of the individuals identified by the client or liaison. You need to point out in writing that you cannot be held liable for not photographing someone if you were not told to photograph a specific person or if nobody pointed out that person to you. Otherwise, the client may come to you a week later and ask why someone or something was not photographed.

It's important that you discuss, and that your contract includes, little things. For example, does the client want images delivered in JPEG, TIFF, or RAW format? Large corporations might prefer to have RAW files. Others might want TIFF files. Clear instructions before the event will help you avoid complications after the event.

Now, if your camera crashes in the middle of a key awards ceremony, you better have a good backup camera ready, because you will be responsible for delivering those images. Sometimes you might complete almost all your work, but there is a computer glitch at home and you lose seventy-five images, including some of the award ceremony. You need to figure out how you'll deal with that issue: If you want to keep that client, you will need to work out a compromise. Offer to give them all of your photographs and agree to adjust

If you don't understand the customer's requirements, don't take the assignment!

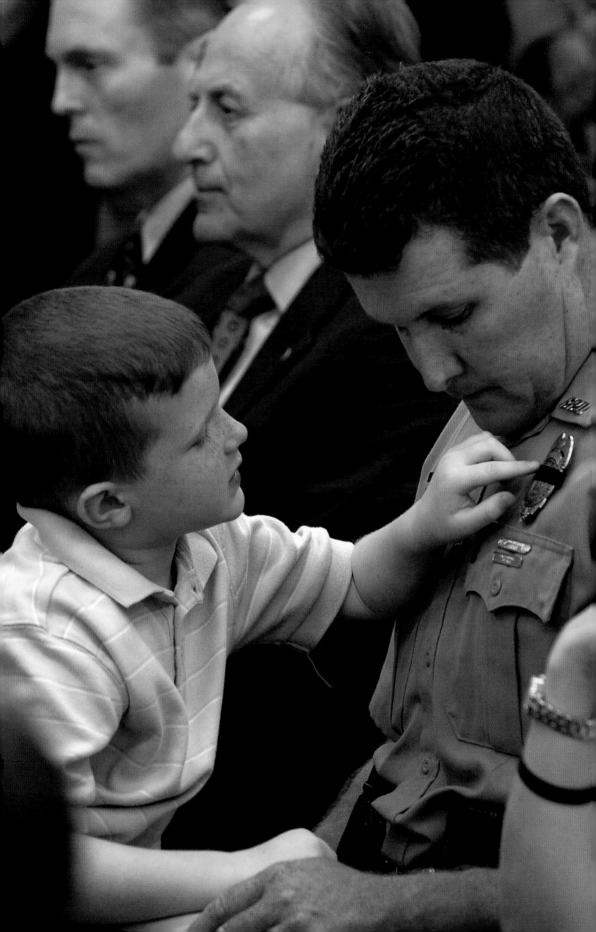

your price. Depending on what was lost, you might end up giving the client all the images.

Because things can go awry, include a sentence in your contact stating that if the client is not completely satisfied, no payment is due. Point out that you are not responsible for events beyond your control (acts of nature or man). Carefully limit your liability to *no payment*. Specifically note that you cannot be held liable for anything more. That sentence may keep you out of court one day.

With a carefully crafted contract, you can concentrate on getting those winning shots and not worrying if you overlook a minor detail. It does make a difference; you shoot relaxed, you'll take more innovative shots, you'll experiment more, and you'll be more productive than if you are constantly checking your list of things to photograph.

ON-SITE STRATEGY

Winning photographs will sometimes fall into your lap. Usually, however, it does take a little planning and coordination. The first step is to visit the event site a little ahead of schedule. If you can stop off a day ahead of time, you can scout out the location. I always look for small alcoves, staircases, walls, etc., where I can pose small, medium, or large groups. I know I will be asked to do so, and I want to be ready when the time comes. I'll also look around for unusual angles (e.g., shooting down from a staircase or balcony). You can also arrive a bit early at the location and do some quick scouting.

If Jim and I are shooting an event together, we'll review our strategy as we drive to the facility. We'll try to figure out what we'll do to get some really good shots during the event. Thus, we both pretty much know what we need to do before we arrive.

Upon arrival at the facility, Jim and I will find a place to set up our equipment. We like to calibrate our cameras so we are on the same page. Our checklist: Are we both on RAW? What ISO will we use? We set the camera to manual at f/5.6 or f/8 with the shutter speed at $\frac{1}{60}$ to $\frac{1}{125}$ second. We set the white balance to 5400K. We double-check to make sure our Quantum Flash T5d-R systems are operating properly. We also double-check the off-camera Q-Flash units.

We then head for the podium where the speakers will stand and look to see what is in the background. Since we are usually early, we frequently ask the caterers or staff to move some plants or flags backward or forward a bit. On some occasions we may have to set up a black backdrop to avoid background clutter or reflective surfaces. We also do a few test shots to see if there is an unusual reflection or a problem with lighting and to take our final readings for our camera settings.

Our next step is to locate the liaison and check in. We'll go over the agenda for the evening and ask about important guest speakers, CEOs, members of the board of directors, political figures, honored guests, awardees, etc. We'll review the need to have all recipients stand still with their awards while we take

STAY ON YOUR TOES

Just because you've taken a few test shots to check on the lighting, don't become complacent. Someone will alter the lighting at some point in the ceremony—usually just before the key presentation of the evening.

With a carefully crafted contract, you can focus on getting winning shots.

Producing winning images for your clients can be easy.

their photograph. This is our last chance to get some idea of what to expect during the evening. Having photographed a large number of events, we know that something will go wrong and substitutions will take place. It is up to us and our liaison to stay abreast of developments.

The next stop is to find the MC and again review the importance of him/her asking award recipients to stand facing me for photographs after they receive their award. The liaison should also tell the MC the exact same thing. We fully expect that the MC will, despite reminders, forget to pose the awardees for the first two or three times. We know it's coming, so we are ready when it happens later in the evening.

I usually shoot from a 45-degree angle toward the podium to avoid having the microphone in the photograph. Jim will cover the other side of the podium from approximately the same angle. This is also a good angle to cover the awards.

If possible, we store our camera bags close to the dais. If something goes wrong, I'll simply walk over to my bag, retrieve my backup gear, and continue shooting. If Jim sees me leave the area, he takes over. No hitch, no loss of photographs—every moment is captured. I can always deal with the mal-

A typical retirement party photo. In a situation like this, use bounced flash or make sure the certificate is aimed upward to avoid glare from the flash on the glass.

function after the award portion of the ceremony.

Next on our list of contacts is the management of the facility. We usually like to take a photograph of them, sometimes with the chef or maitre'd. We'll send them a complimentary photograph with the suggestion that they contact us if any of their guests ever needs a photographer for an event at their hotel.

ACTION SHOTS

We are now ready to start taking photographs. This is where years of practice pay off. We prowl the site looking for genuine human interaction, like guests hugging each other, a look of surprise at seeing an old friend, or a warm handshake. It's funny, but after an event we frequently discover that we have both managed to capture very similar emotions and actions at different times in different parts of the room. After a while, you begin to know what is going to happen and you simply wait until it does, then snap the shutter.

THE RIGHT EQUIPMENT

If you use the right equipment, you'll tend to get better results. The right

equipment can involve using an old film camera and flash set to $\frac{1}{60}$ at f/5.6. Newer equipment, however, does offer today's photographer more flexibility and better control, with instant, on-the-spot verification. Our newer equipment is also less likely to break down at the wrong time.

The following describes some of the equipment we use. Our list of key equipment *does* change as new equipment is introduced or when we discover a new system.

Flash Equipment. Jim and I tend to dislike shadows caused by directed flash units. (Most on-camera flash units point directly at the subject.) We've switched over to using Quantum Q-Flash T5d-R units with a domed cover diffuser aimed at the ceiling. This does a pretty decent job. Sometimes you have to angle it forward to a 45-degree position and sometimes directly at the subject. After an hour or so, we may decide that we have sufficient images

This photo of the wedding cake involved three people: the photographer, someone to hold an off-camera flash, and another to hold a large, overhead reflector used to bounce the light softly downward.

and can think about doing something special. I typically will pack up my gear and pick up a Q-Flash on a stand. I'll walk around with Jim, holding the Q-Flash system high over my head pointing it down, or at a wall, or close to the ceiling. This will produce beautiful light with minimal shadowing. Jim's camera will automatically trigger the Q-Flash so the results are flawless.

Camera Equipment. When we work events, we will use different lenses. Jim prefers an extreme wide-angle lens (the Nikon 14–24mm or 17–35mm) and I'll typically use a Nikkor Silent Wave 28–70mm 1:2.8 lens. My next favorite event lens is the Nikon 18–35mm 1:3.5–4.5, followed by the Nikkor 12–24mm 1:4 G ED lens. However, since Jim is shooting with a wide-angle lens, I have those lenses handy, but may not use them unless I know I have a group shot I need to cover. I carry a Nikon 85mm 1:1.8D lens and a Sigma 30mm 1:1.4 lens that I'll sometimes use in low-light situations. I enjoy working with a Nikkor 70–180mm 1:4.5–5.6 D lens for distant shots; it's slower, but very sharp. I may have to remove the diffuser dome off the Q-Flash and aim it directly ahead when I use that lens since I'm trying to photograph people on the other side of the room without them being aware of me. Finally, if I am restricted from the area around the dais, I might have to use an Olympus 90–250mm (180–500mm equivalent) 1:2.8 lens on a tripod; this frequently happens if there are security restrictions in place that prohibit the photographer from approaching the dais area.

We both independently check with the liaison and host during the evening. There is very little chance that one or both of us will miss someone or something important, because we are consulting with our contacts throughout the evening. It's pretty difficult for anyone to come back to us after an event and complain, because two of us are constantly checking to make sure we've covered everything.

Otherwise, we cross paths, going outdoors and back indoors, constantly in motion looking for those special photo ops. The result? Great photos, lots of photos, and a satisfied customer who knows we were out there working hard.

Former Virginia State Senator Devolites with two beautiful Korean girls at a groundbreaking ceremony.

6. The Importance of Lighting

Understanding and being able to work with different types of lighting will help you become a really good photographer. True, with many of today's new digital cameras, you can leave everything on automatic or program mode and produce very fine results. Even flash photography is reasonably easy to master: f/5.6 at $\frac{1}{125}$ or f/8 at $\frac{1}{60}$ pretty much guarantees acceptable results.

However, you should strive to advance beyond "acceptable" results into "exceptional" photography. To do that, you must fully understand just how far you can push the limits to obtain some really interesting images.

The following section serves as a general guideline to what you can use in various locations.

TYPICAL LIGHTING SCENARIOS

Though we've used the words "typical lighting," you all know that each individual assignment brings its own special circumstances that you must deal with on the spot. For example, when shooting with available light, will it be bright midday sun or late evening? Will it be partially cloudy or raining? If you are using flash indoors, how high are the ceilings? What color is the ceiling? How close to center stage can you get? Will you have mixed sunlight and tungsten or fluorescent lighting? In the paragraphs that follow, we'll show you some of the strategies we've used to handle these different lighting scenarios and the results of our efforts.

Available Light. Many outdoor events can be photographed successfully if the weather cooperates. A light, high cloud cover offers beautiful light with minimal shadows. Lighting can improve as it gets cloudier, but eventually it will get too dark and you'll need to add fill flash to brighten the scene.

Flash. In very harsh sun, you'll need to use a fill flash to help control heavy shadows under the eyes, nose, chin, etc. You'll normally have to push the flash power up a notch or two to make things work. In that scenario, it is best to have the subjects turn their backs to the sun and use your fill flash at a slightly lower output level. You'll also want to use your fill flash if heavy clouds roll in or when photographing in the shade to boost the light falling on your subject.

Most indoor venues offer a combination of tungsten or mixed light (fluorescent or high-intensity lights). Sometimes you might want to adjust your white balance setting to the tungsten or fluorescent setting and try photo-

> In very harsh sun, you'll need to use a fill flash to control heavy shadows.

ABOVE—(LEFT) A nice image photographed outside under the cool light of a large shade tree. (RIGHT) Compare this image, which was taken with a single off-camera fill flash with the portrait made in natural light. BOTTOM—On-camera fill flash illuminated the subject, but not the background. The clouds helped create a softer image without deep shadows.

graphing without flash. Indoor photography, we've found, generally works best when we use flash.

1. *On-camera fill flash.* On-camera flash is a pretty common method of illuminating your subject. Our flash units are usually used with a domed diffuser or other type of diffuser, though there are times when we don't use a diffuser. Gary Fong's diffusers also produce nice light.
2. *Off-camera fill flash.* Because we work as a team, one of us can hold an off-camera fill flash (typically equipped with a softbox) to light the subject. Control is easy: the person holding the flash unit moves forward and backward until the light is perfect.
3. *On-camera and remote, off-camera fill flash.* We frequently set up one, two, or three Q-Flashes on tripods. The flashes, which are typically fitted with a dome diffuser and aimed at the ceiling, are fired remotely from

TOP—(LEFT) An example of off-camera, dual fill flash units providing light from both the right and left. (RIGHT) An example of on-camera flash combined with off-camera fill flash (placed to camera left). BOTTOM—An example of light bounced from a low, white ceiling and coming back down as beautiful, natural light.

the camera to remote receivers. Using this method we can avoid shadows and fill the subject area with light that highlights the action.

4. *Bounced flash.* You've probably gotten the idea that we bounce our flash units off the ceiling at most of our events. Well, you're right. We find bounced light provides a more natural look to our images, and as long as the ceiling isn't painted some "off" color, it usually works just fine.

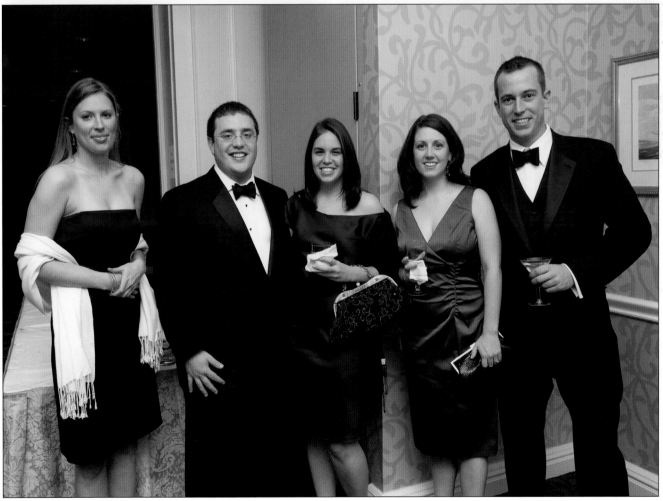

TOP—An example of a photograph taken with a Nikon D3 camera set to ISO 800 with a Nikon SB-800 flash aimed backward. BOTTOM—(LEFT) To illuminate both the car and the individual, we used on-camera flash combined with a radio-synched fill flash with a softbox that was handheld, high overhead from the end of a tripod and pointed down. (RIGHT) Notice the beautiful light streaming down from a diffused flash bounced off the ceiling for a gorgeous effect. Look at the white boxes, and you won't see any blown out features. Look at the nametag, and you'll see that the light was coming from the ceiling.

5. *Feathered (or backward) bounce flash*. Jim began experimenting with aiming his flash unit backward when photographing indoors to further soften light spilling onto his subjects. This technique requires him to use higher ISO settings. Fortunately for us, the Nikon D3 allows him to use ISO settings that once were impossible (e.g., ISO settings above ISO 1000) without digital noise. The D3 will allow Jim to continue this method in the future and will likely further alter our shooting style. One nice thing about photography is that new technology allows us to develop new and better methods for serving our customers.

6. *Directed flash*. Since we operate as the JPG Photo Events Team, we can alter our shooting style in the middle of an event. When we arrive on location, we'll usually equip one radio-controlled flash with a softbox and place it on a tripod. Once we feel we have both captured a few hundred great shots, I put my camera aside and pick up the Q-Flash on the tripod, lift it high over my head, and point it where Jim needs more light.

This ensures great results since the whole system works together in either QTTL or in manual mode where we know what the output will be.

7. *Diffused flash.* We typically use a Q-Flash with a domed diffuser head on the flash. We can aim the flash directly at subjects, or we can aim it at a 45-degree angle, or aim it at the ceiling, or off a wall on the right or left side, or even backward. Diffused, bounced flash is almost guaranteed to produce wonderful lighting.

COMMON PROBLEMS WITH FLASH

We typically face three problems with lighting in our event photography assignments: glare, shadows, and gray or bright backgrounds.

Glare off reflective surfaces and the flash being reflected back into the photograph by glass are fairly typical problems we encounter at some events. In some cases, this is unavoidable using only an on-camera flash. By adding an off-camera flash, glare can be avoided.

1. Glare or reflected light from the flash can be a big issue at venues where you can't take the time to set up special lights. The way we handle most glass issues is to bounce the flash. Sometimes that simply won't work, and then you have to look at the image and decide whether to keep or reject it. We work at one venue where there are three glass walls that allow the guests to see outdoors. There is nothing we can do in that

This was an event assignment, not a commercial assignment. So, we simply did not have the time to set up a bank of lights outdoors: all our lights were set up inside the dealership for use at the party.

venue, because in addition to three glass walls, the ceiling is high and it also has glass in the roof to allow sunlight to enter during the day.

2. Shadows from on-camera flash can detract from an image. In some cases, however, there is nothing you can do, given the time constraints of an event. Just be aware of shadows and switch to bouncing your flash, adding an additional diffuser to reduce the impact of the shadow, or raising your flash as high as possible to push the shadow down or behind the subject.

3. Flat or bright backgrounds are also fairly typical problems you will face. Sometimes you can't do a whole lot to fix the issue during an event; this is not a portrait session where you have the luxury of carefully metering both the outside and indoor lighting and then carefully calibrating your equipment for the perfect exposure. If you get too involved in correcting one lighting scenario, you might miss another shot of something that the customer really wanted photographed. Balance your need for the perfect shot against the reality of the ticking clock.

A terrific view of Washington, D.C. is a great background for this portrait, but the dull weather detracts from what would have been a perfect shot. The subject, however, looks beautiful.

7. Shooting for the Gold

In this chapter, we'll let some of the photographs do the "talking" for us. We'll show you a variety of shots and allow you to decide if a particular approach will make sense for you.

FACING PAGE—A favorite image. Ambient lighting produced a stunning image at this wedding. The photograph was taken with a Nikon D3 at ISO 5000.
RIGHT—This is a good image. Taken live on stage, without flash, using stage lighting. Taken with a Nikon D2Hs with an ISO of 800 and settings of f/4.5 at $^1/_{125}$. The image was converted to black & white and the background was replaced using Photoshop.

WHAT MAKES A GOOD SHOT?

We all know what a bad shot is: It's an under- or overexposed image. It is out of focus or blurred. You've cut the head off a person. Someone is blinking or yawning at just the wrong moment. The person's animated conversation makes him or her look ridiculous. People's backs are toward the camera. Those are simply discarded.

Anything that does not fall into the reject category falls into the "good" category. Most of you probably take good photographs. All of your "good" pictures should be marked with a #3 rating (or given a color, such as red) to show that though they are not rejects, they are not your very best.

WHAT MAKES A GREAT SHOT?

Most of you are capable of producing great shots. These are the shots that capture a special moment. I went out on an assignment with a pretty good photographer who just wasn't ready to go professional. He and I shot the same event. Afterward, he gave me a CD with almost a thousand digital images on it. I carefully reviewed his images and began to see a pattern: his first shots were almost always great. He saw something and captured it. Then, because he was uncertain of himself, he shot another, and then another, and another. The first shot was great. The remaining shots declined from good down to rejects.

This is a great photograph. The lighting is perfect, composition is strong, and it captures action, expression, and emotion. Why isn't it an "outstanding" photograph? It's because of the glare.

Why? If you capture someone doing something spontaneous, you capture something special. Take two shots (especially with flash) and the subject(s) suddenly realize they are being photographed. Their personality will change (you can see it happen). Most will turn toward you with a great smile (nothing wrong with that, but it is a "public face," not an intimate moment). They'll usually ask you to take another photograph of them with their friends. Magical moment? Gone.

You'll probably take a lot of "great" shots during an event. Great candid shots, well-posed group or individual shots, images with good color, nice composition, and great views of the event. Mark those with a #2 rating (or give them a color, such as orange).

WHAT MAKES AN OUTSTANDING SHOT?

Although Jim and I are very good at our work, we sometimes both exclaim, "Wow, you really nailed that one!" Something happened and everything came together: strong color, great lighting, great composition, strong emotional appeal, action, and that special quality that causes people to say "wow!" We normally come away with ten or so "wow!" shots per assignment. Those are given a green color or rated as #1 in our ranking system.

This is an outstanding event photograph. Why? Because the lighting is great with no shadows. Also, the subject is not only beautiful, but she fits into the setting perfectly. Finally, note the Aston Martin logo in the background. What about the light-colored napkin? Yes, it does subtract slightly from the image, but this is event photography, not portraiture. What we've done is produce the kind of image the client was looking for!

ANTICIPATING ACTION

Great shots are yours for the taking if you can learn to spot action and be ready to capture that image. You've got to learn to spot those events as they start to unravel and capture them with one shot (or, a maximum of two shots), and then move on. Otherwise, they become great, *posed* shots. The smile of a child milliseconds after opening a new toy, the joy of a boy and his dog, the smile when greeting an old friend, the pleasure of winning a coveted award, the enjoyment shown when someone is surrounded by his or her friends—these things all happen. When you can combine these moments with a background that is important to your client you are well on your way to shooting gold-medal-winning shots.

FACING PAGE—This image shows a beautiful woman, who is an important executive at Cardinal Bank (the host of this event), with the bank's logo in the background. This is what event photography is all about: making the client look good (not difficult in this case) and producing an image that highlights the company or its products. BELOW—Winners at the Middleburg, VA, spring races. An SB800 fill flash was used to supplement the natural light.

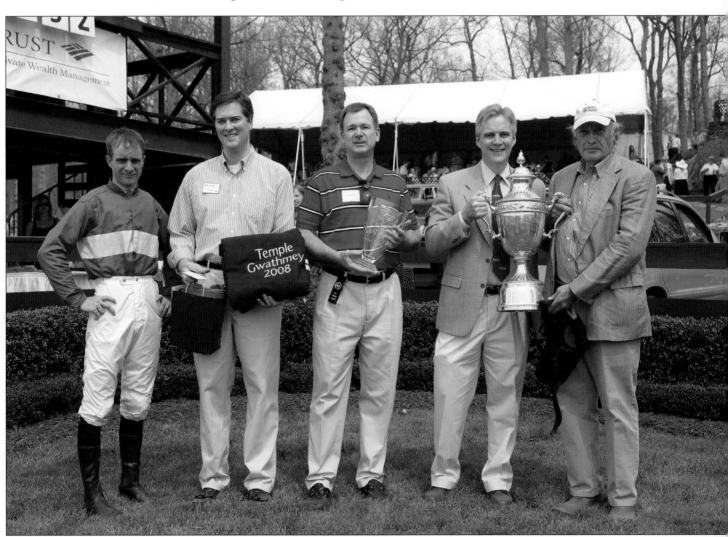

8. Problems and Disasters

We know that we will encounter a series of problems at every event we cover. Part of the challenge of being a photographer is learning to overcome obstacles. So, for us it is a challenge to see how we will overcome those problems and come out shining.

AMBUSHED!

Despite all prior preparation and coordination, we continue to be notified of a major change in plans at the very last second. We recently photographed an awards ceremony where we spent fifteen minutes carefully setting up and testing our lights in preparation for the awards portion of the event. We then

When first asked to line up for a photograph, most people will form a long, extended line.

It is up to us, as the photographers, to quickly organize people in a nice formation.

began taking pictures of the guests, having been assured that the group shots would take place after the awards. At that point the contact came up and informed us that they would be taking group shots before the awards. She then directed about fifty people to gather in the corner of the ballroom. You don't have time to do anything but react: Jim took over getting the participants together while I took the two off-camera flash units down and repositioned them on either side of the group. With that done, I began pushing chairs out of the way, asking guests to move away from their tables, and sliding tables out of the way. By the time I was done, Jim was ready, and we got the winning shot (Jim took six shots, expecting one to be a keeper).

TAKING CONTROL QUICKLY

When the MC announces it is time for people to come up for the group photo, people typically will form a long line extending across the room. You'd need a fish-eye lens to capture that gaggle of people! It is up to you to quickly and politely get people to form a tight, cohesive grouping with proper alignment and facing in the right direction. Every second counts!

DEALING WITH BACKGROUNDS

We wish we could offer a better solution to deal with ugly backgrounds. We can't. You've all had the EXIT sign illuminated over the head of the guest speaker (I guess that's what Photoshop is for). You also have ugly wallpaper and only a few minutes to pose seventy-five people. You just have to deal with

it. Sometimes you can't fix everything. However, we do carry a large duffel bag with a black backdrop stuffed inside along with two heavy-duty tripods and a pole to hold the cloth in place. We can accommodate small groups with that (perhaps ten to twenty people), but when photographing a large group we must look for an unusual location (and pray you have the time to get people there and back without your client growing upset).

TOP—We simply did not have time to set up a wide background for this shot. We had only a minute or two allotted for photography.
BOTTOM—In Photoshop, we combined the photos of the art project the group was working on with one of the group shots, making the event photo much more meaningful.

LEFT—A microphone will leave a shadow and block a beautiful face. ABOVE—This is a much better picture, because the microphone is less evident against the subject's hair.

MICROPHONES

Sooner or later you'll have to deal with the guest of honor or some other dignitary speaking in front of a microphone. If possible, shoot from a 45-degree angle so the microphone isn't in the middle of the face. Try to hide the microphone (at the same time, you are getting great pictures of the speaker) in the background or against a black tuxedo or black dress. Sometimes it works. Sometimes not.

REFLECTIVE SURFACES

I work at an event facility that has three major wall areas made of glass. It's a beautiful location with a view outdoors that is hard to beat. One reason we dress in black is so that we don't stand out in reflections. We also like to bounce our flashes off the ceiling to avoid having the flash bounced right back into our cameras. Sometimes we use a tripod with a Q-Flash mounted on it, and one of us will raise the tripod up overhead while the other shoots. If your back is toward the glass or reflective surface, you'll get away with taking those photographs with minimum glare. Figuring out how to deal with reflective surfaces is one of the first things we do upon entering a new location. Some-

times the solution is to place several off-camera flash units on tripods pushed almost to the ceiling and pointed down or bounced down.

Eyeglasses. You are going to encounter situations where many subjects are wearing eyeglasses. If you run a portrait studio, you can work around this problem—but not in event photography. We usually can't engage all the people wearing eyeglasses and ask them to move their glasses this way or that way. We're busy doing other things. The best way to eliminate the reflections is to use an off-camera flash, bounced flash, or a flash on a bracket. That eliminates the flash being reflected off glasses, but not the optical effects of thick lenses. You'll have to accept those.

BLINKS

One of the best innovations in photography is the digital preview! Yes, you can see if someone blinks. In the film days, you'd have to take picture after picture and still not know if someone blinked. We still take quite a few pictures of groups, anticipating that someone will blink. Some people have the uncanny ability to blink as the flash goes off. If we encounter a blinker, we'll frequently photograph together, quickly. One of us will get it right. A good rule of thumb is to count the number of persons in the group and divide by three; the result is the number of clicks it will usually take to get a great shot. Believe it or not, the first shot is almost always the best.

OFF IN THEIR OWN WORLD

You need to be able to control groups of people: quickly, efficiently, and politely. Jim spent his career in the military and is able to command attention. He tells them that he will take six pictures. He'll say, "Look at *me!*" (Someone is almost always looking off into space, and that will capture just about everyone's attention. If he takes six images, the odds are reasonably good that everyone's eyes will be open.

But when all else fails, a steady hand (if you are shooting unsupported) or a tripod (if you are not too steady) will yield a Photoshop opportunity. Using Photoshop's Layers, you may be able to add those closed eyes from another shot, and with a bit of practice it will look as if all of the subjects followed your instructions and looked at the camera.

LADY IN THE WHITE DRESS

In most formal group shots there will be a lot of muted or dark-colored outfits and one individual who will be dressed in a white dress or a really bright, vibrant color. If possible, assign that person to the middle of your group. The eye will go to that spot, and it might as well be in the middle instead of off to one side.

CAN'T SEE YOU!

If we have problems lining people up, we'll tell the group that if they can't see the camera, then they will not be in the picture. We ask if anyone is having

TIPS FOR BLINKERS
You can start off by saying, "Folks, one thing we like to do is photograph people with their eyes open." This usually gets a chuckle.
You can also be sneaky. Simply announce, "Alright, everyone . . . on the count of three: One, two (snap your picture), three (take another photo). Okay, I lied (everyone laughs and you snap a fourth photo)." Now you have four images, and one of them is bound to be okay.
Another tactic is to say, "Okay, close your eyes. On the count of three, open your eyes." When they open their eyes, you take their picture. This works great with children.

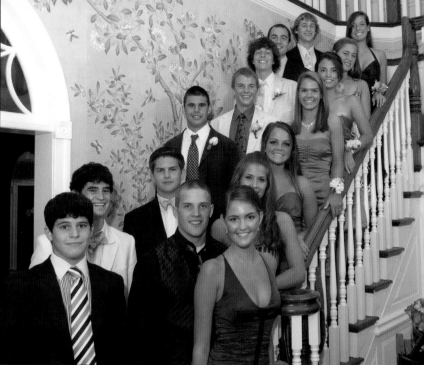

LEFT—We were able to photograph eight subjects by using a staircase. RIGHT—Here we were able to capture sixteen kids by posing them on a staircase.

trouble seeing the camera. If so, we'll invite them to come up front or to move to one side.

SPACE LIMITATIONS

I always hold my breath when it is time for the group to gather. If we are lucky, the liaison has given us the right number of people in the group, and we've arranged the right number of seats and a place for people to stand against a reasonable background. Sometimes even the best-laid plans fall apart as friends, family, or other unexpected guests are invited to join the group. We've mentioned the importance of scouting out your location before the session. Here is where doing so will be especially useful. We may have to recommend moving to a different site (that means taking down and setting up our lights again, so we don't like doing that). Sometimes there just isn't anywhere else to go in the amount of time we have. No matter what happens, we make sure to inform our liaison of what we can and cannot do. (*Hint:* We like to use staircases. You'll often find a staircase in most large hotels or conference centers. It's pretty easy to get a quick shot of a lot of people using stairs.)

DEALING WITH DISASTERS

Sooner or later, something will go dreadfully wrong. You'll get stuck in traffic or have to go to the emergency room at your local hospital and miss the grand opening. Your flash unit crashes just before the awards are handed out and you didn't bring a backup flash. You'll arrive at the event and realize you've left your memory card back in your computer. You can even get your dates mixed up and show up on the day after the event.

As a professional, you must learn from your mistakes and work to eliminate future ones. The following tips can help you avoid problems:

Before the Event
- Make sure that you and your client both understand exactly what you will do, who you will have to photograph, and what you are expected to deliver.
- Always send a confirmation e-mail with the date fully and clearly identified (e.g., "We'll see you next Thursday, November 10, 2010 at 6:00 PM").
- Make sure you have your liaison's telephone number (in case you get stuck in traffic).
- Always do a Google map search for the address, use a GPS system, or drive out to the event location the week before the event.
- Make sure your camera bag has everything you need for the assignment. You should develop a packing scheme for your equipment and follow it precisely every time you pack. This will help you locate your equipment quickly.

During the Event
- Show up early. If you discover you've left your sync cord behind, maybe you'll have enough time to slip out, race home, get the cord, and race back in time for the event. You might also keep an eye open for camera shops along the way to the event site, just in case.
- Always have a backup camera and flash (it could be your partner's equipment).
- Always have spare batteries.
- Always check every single setting on both your camera and flash unit.
- Coordinate your camera/flash settings with your partner.
- Take a test shot. Check the histogram. Is everything working?
- Stay in constant contact with the liaison and the principal players. If there is an issue, bring it up immediately and ask them how they would like you to handle the problem.

Stay in constant contact with the liaison and the principal players.

After the Event
- Download your images and immediately back them up.
- Do not remove your memory card from your computer until you have verified that all the images have been properly downloaded.
- Don't use the automatic erase/reformat feature some download software programs offer; it's best to reformat your memory card in the camera after everything has been reviewed.
- Place all of your RAW files in a special storage area for future retrieval. Don't erase *any* of these files, including the rejects, for at least a month or two after the event.
- Keep your JPEG files in a folder that is designated for the specific event category, and list each event by title. Retain these files for at least a year.
- If your computer suffers a meltdown or if you miss the event because of something beyond your control, you must have a strategy to deal with

the problem. Obviously, you cannot bill the client, because you failed to produce. Your contract must have a provision excluding you from liability in the event of a disaster beyond your control.

However, all that does little to protect your reputation. Obviously, you should provide the client with a full explanation (the drawbridge was stuck in the open position) as soon as possible. Good or bad, people want to know what is happening.

You might then offer to photograph their next event at no cost. It may be a bit costly, but your reputation will survive and may be enhanced. Disaster recovery is not a lot of fun, but if handled properly, it will demonstrate your professionalism.

Use of a muted QFlash against the setting sun produced great light for this portrait.

9. Shooting as a Team

Part of our success as event photographers is that we work as a team. There are many benefits to working together. We'll take a look at some of them in this chapter.

MAKE A SHOOTING PLAN AND FOLLOW IT

When we arrive at a location, we pick the spots where we will shoot. Where will the awards be bestowed? Who are the VIPs, and where will they stand? We must pick the optimal position, yet not distract or detract from the event. We must blend in and disappear. After one event we photographed, the customer and several of the attendees commented that they had not even noticed us during the event, yet we captured all the shots. This was perhaps the best compliment we have ever received.

WINNING PHOTOS

During the course of every event we cover, we know we are going to produce some excellent images that, had we worked independently, either of us might have missed. It's not about the individual; it is about producing really great images that make our clients happy that they hired us to photograph their event.

BACKUP

Photographing the CEO giving an employee an award is a pretty significant moment. I'll be photographing the event on one side of the dais while Jim is shooting from the other. Even though we are pretty good at watching for blinks, the odds are that one of us will catch the CEO or award recipient blinking. The odds are also in our favor that if I catch the blink, Jim won't. All that matters is that *we* captured the moment.

If my camera or flash unit fails during the course of an event, Jim steps up. There is no need to panic, even if the president of the United States walks into the room, because Jim is shooting. It takes me only a few seconds to return to my camera bag, pick up my backup camera and flash unit, and get back to work. Imagine having to explain to your client why you missed the president congratulating the award winner! With a team approach, this simply doesn't happen.

> Part of our success as event photographers is that we work as a team.

Teamwork allows you to use different lenses to produce totally different images!

DIFFERENT LENSES

Although Jim and I both shoot with the same settings (ISO, aperture, shutter speed, and white balance), we use different lenses. That means we constantly produce different images; the final product will always look different because we use up to four different lenses during the course of an evening.

DIFFERENT SHOOTING STYLE

Because we use different lenses, we use different shooting styles. Jim prefers working with a wide-angle lens, and so he needs to get up closer to people. Jim is a master of quickly making people comfortable; he has to do this because he is working close up. This is a great asset when working with groups

as well. The wide-angle lens also allows him to be especially creative in some of his shooting.

Because Jim is shooting with a wide-angle lens, I can concentrate on taking pictures of people across the room. Because they are not aware of my presence, the smiles are more genuine and the actions more natural.

When we compare the results at the end of the evening or the next day, we have roughly 40 percent of all images taken with an extreme wide angle, 25 percent with a moderate wide angle, 25 percent with a moderate telephoto, and 10 percent taken using a telephoto lens. These are rough estimates, because in some situations we'll have more group shots, and at other times the lighting conditions will not allow for the use of telephoto lenses.

GREATER FLEXIBILITY

Because we are shooting as a team, I know I can put my camera down at any time during the event and pick up an off-camera Q-Flash system to help Jim create more interesting images by bouncing the light downward, sideways, or upward. This is actually a lot of fun because this is when the creative process really kicks in. Sometimes we nail it. Sometimes the results are a little too creative and we'll discard those images.

CONSTANT ACTION

With two of us working an event, the host and hostess are constantly seeing flash units firing. They know they are getting their money's worth. They know that we are fully committed to accomplishing the job. They are much more likely to hire us again in the future, and it's not unusual for the hosts to suggest we sit down and relax for a few moments. Many times the host or hostess will bring us some water and tell us to take a break. When that happens, we know that they will speak highly of us to their family and friends.

There are always potential clients who are impressed by our dedication.

GENERATING CONTACTS

Jim and I both take advantage of lulls in the action, or when someone comes up to ask us questions about photography, to exchange business cards. There are always potential clients out there who are impressed by our dedication to the job. Because we work as a team if we stop to talk to someone for a few minutes, nobody really notices. We do, however, try to keep those conversations brief.

I have photographed hundreds of events during my career as a photographer. I've worked alone and with other photographers. Working as a team is much less stressful and almost guarantees images that will generate new clients for the future.

10. After the Event

Opening ceremony for Southwest Airlines at Dulles Airport.

With careful planning, a good work strategy, plenty of experience, great equipment, and a friendly rivalry to take the best shots of the event, Jim and I are positive each of us will come home with some really outstanding images. If we each come home with only 50 percent "keepers," we will have a collection of three to four hundred good/great/outstanding photographs, and our normal performance is much higher.

Now comes the difficult part. You are already tired from lugging all your camera gear around taking photographs and really want to sit down and watch some TV before heading off to bed. Jim and I, however, know we've just started. We have at least two hours of work ahead of us. Getting images to our clients the first thing the next morning is something that sets us apart from some of our competitors.

When two individuals work together we must both share a compatible, if not common, workflow. How we think about taking, naming, processing, and displaying our images must be resolved before the job starts. We use the Nikon shooting menu file-naming option to create unique file names to differentiate between our three or four different cameras. Jim uses "D3A" and "D3B" to differentiate between his two D3 Nikons when naming files. Often in the contract we stipulate how the images will be named. As we may choose to retain the RAW images after an event, we reserve the complete numbering system for quick reference if we need to reprocess at a later date to a different crop size or angle.

PROCESSING RAW IMAGES

The first step is to download the files in the memory card to our respective computers. Then we both open and process the images using Capture One Pro. We both shoot in RAW, and Capture One Pro provides us with the processing power that we both are comfortable using.

If we need to make an adjustment to the white balance, we can both choose the same Kelvin degree setting and within seconds every single image is captured at the proper, uniform setting. Often we will use one of the many gray card reference shots we take during an event as we move from room to room

to ensure we are in balance and the colors match between the several camera outputs we use. Next, we'll run through every image to correct horizons; with Capture One Pro, this takes only a second. We then go back through each image and crop as needed. The final step is to balance the brightness of the image. Sometimes you are just a bit too far away from the subject and a boost in brightness works just fine; other times, you need to subtract a little light. Once all these corrections are made, the images are converted to JPEG format. Processing four hundred RAW images might take an hour or so.

DISCARDING MARGINAL IMAGES

Now it's time to open up Nikon View (Jim prefers working with iView MediaPro) to see the results. Here is when the selection process begins. What do we discard? We always have a few shots where the flash failed to fire; those black shots are quickly deleted. There are shots where the focus was off; these images are gone. Any image where someone is blinking is a goner. People talking sometimes have an unflattering look; those images are history. We always have a small number of images where someone simply doesn't look good; these too are gone.

> Once the corrections are made, the images are converted to JPEG format.

FIRST-ROUND "KEEPERS"

Any image that is technically sharp, well focused, and properly illuminated gets through the first round of edits. The next step is to fine-tune brightness, adjust the horizon, and crop out unwanted items from the photograph. That step is usually done in Capture One Pro and Photoshop.

RATE THE IMAGES

We each have our own method of going through the images we just shot. Those that passed the first round are sorted into "good," "great," and "outstanding" categories (some software programs allow you to assign colors or numbers to each photograph). We can now have the software organize all the images based on their rating.

TRANSMITTING IMAGES

Once we have independently identified our keepers, we are ready to compare our joint work. Jim and I use a software program called Transmit to send our

FACING PAGE—Great shots are sometimes incredibly easy—if you are prepared.

images back and forth to each other. We both use high-speed broadband connection and can move images through the Internet space very quickly. We maintain one site with a 40GB capacity, which will accommodate a job of any size. Using the FTP (File Transfer Protocol), we will load the image onto the server for collaboration and review. I subscribe to the Verizon FIOS system, and Jim uses a high-speed Internet connection so I can transmit all three to four hundred of my keepers to him for his review early the next morning.

PICKING THE RIGHT ONES

As much as I enjoy photography, I don't like wading through stacks of similar images. Your client won't be impressed when you dump hundreds and hundreds of similar images on their computers. So, it's your job to pick the very best and hold the rest back. Who wants to see a picture of the host waving to the folks on the right, one of him waving to the folks in the middle, and one of him waving to the folks in the back? Pick one or two and assign the rest to a "backup" category.

Why do I say this? Imagine going to a restaurant with a large buffet table. Will you want to sample every single dish in the place? All are good, but will you fill plate after plate with every single offering? No. You'll choose a sampling of what you really enjoy and go back for seconds. Okay, maybe thirds. Same with your clients. You'll impress them more with fifty stunning images, one hundred great images, and possibly fifty good images that include some people who might not have photographed well.

WHO SHOULD OWN THE IMAGES?

When I first began photographing, the absolute rule was that you, the photographer, had to keep control over every single negative and image and never, ever let an original leave your studio. As a result I quickly accumulated a huge collection of negatives arranged by date and event. I was overwhelmed with paperwork and was only generating a few odd sales after an event. I understood why I needed to maintain total control over my images, but in practice it really wasn't very profitable.

I then went through a period when I simply told the clients that I would turn over all negatives to them and allow them to do their own printing. I would always offer to handle printing, but generally speaking I left that option up to them. I compensated the offset in income by raising my hourly fee to cover the events. Not having to produce, sort, deliver, and file the images was not only much less of a burden, it actually improved my overall workflow as I was able to finish a job in days instead of weeks.

With the advent of digital capture, I began to swing back in the other direction. I still offer to turn over all my images to the client, but I tell them that we will post our images on a password-protected fulfillment site where their guests can see their images. If they like something, they can order prints in just about any size or finish directly from the fulfillment website. I leave those images at the fulfillment center for a much longer period of time and don't have to worry about any further sales; once a month, a check arrives detailing sales during the previous month. This is a service my clients appreciate.

U.S. copyright law gives you, the photographer, the copyright to any image you take, so ownership of the image will always remain with you, unless your contract stipulates that you are performing "Work for Hire" or you specifically assign all image rights to your clients.

I would encourage you to assign limited or specific rights over the images to your clients, but maintain the copyright to your images. With today's computer systems you can store a huge number of image files and can one day retrieve them should the need arise.

Eventually, you may decide to clean out some of your digital files. Some might always be worth keeping (e.g., a president's visit to your community), but do you really need photographs of the shoe salesmen's convention that took place twelve years ago?

You'll need to evaluate your own situation and decide how you wish to proceed with your business.

A good action shot is always worth keeping!

We never delete images when there is only one shot of a particular person.

What about the "good" photos relegated to the backup category? Keep those in reserve. Don't show those. If the client wants to know why so-and-so was missing, you have a backup disc. Be upfront with the client: "Yes, I have more images, but these were the best and I felt you deserved only the best. I'll gladly give you my backup images at no cost with the understanding that these don't meet my standards. They are yours to keep." You've solved some potential problems, and you've given your client a little bit extra while maintaining your reputation.

If our schedules allow, we both sit down and review all our images. Otherwise, Jim will compare, rank, and select the final series of photographs. We'll compare photographs, and if Jim took a better shot than I did, my image is gone. Sometimes I'll hit the same subject just a fraction of a second later and there will be something special about my image; if so, it stays. We'll go through all the images, gradually reducing the number we will submit down to something in the two-hundred-image range. We never delete images when there is only one photograph of a particular person because we simply don't know who that person is and how important he or she may be to the event organizers.

PRODUCING PROOF SHEETS
Several computer software programs will allow you to quickly and easily prepare photographs for submission to clients as an attachment to an e-mail. That

is one method of showing the customer that the images are ready and the session was a total success. These e-mails can be sent out before the client heads off for lunch the next day.

PRODUCING CDs OR DVDs

We typically produce a CD or DVD with the photographs of the event after we have narrowed down our images to a manageable number. We burn the files onto printable CDs or DVDs. That allows us to use a program (we use Epson Print CD) to print special covers for these CDs or DVDs. This printing adds a professional touch to the submission and includes information on how to get in touch with us. We then package the discs into a nice, rigid plastic cover that has a sticker with our name and address attached.

SUBMISSION OF THE IMAGES AND THE INVOICE

Our contract usually stipulates that we deliver the final product within five working days of the event. Many photographers don't enjoy postproduction processing, and they may take a few weeks to complete their assignment. We work the opposite way: we aim to get those CDs or DVDs delivered as soon as possible—even if it means driving someplace to drop them off. If not, we'll use a courier service, FedEx, and/or registered mail using first- or second-day delivery. Delivery charges are included in the invoice, which is included in the submission.

SAVING THE FILES

Your final act is to safely archive all of your RAW files (save these images for one year, if not longer). All of the JPEG images should be archived in a permanent file where you can locate them quickly. In my system I have folder called "Events," and I list my assignments by name for ease of recovery.

Some clients will occasionally call me back and ask me to help them find a specific shot. In our contract we carefully state that we keep all files for thirty days and then purge our system unless otherwise requested. We don't charge clients for holding their images for up to a year. We'll hold them longer, but we'll want them to sign up for another shoot.

Your final act is to safely archive all of your RAW files.

11. Fulfillment

The "fulfillment" phase of event photography provides you with added flexibility and potentially added income. There are several ways in which this task can be handled. We'll outline your options in this chapter.

THE CLIENT PRINTS AND DISTRIBUTES

The easiest method is to turn over a CD/DVD with all of the images from the event to your client. Many clients prefer this option. The client then is responsible for printing and distributing photographs to all of his/her guests. This leaves you free to move on to your next assignment.

Some clients like this option because it gives them the opportunity to pen a few nice words of thanks for their guests, thus reaffirming their bonds. Politicians, in particular, like to stay in touch with their constituents, and this is how many of them prefer to work.

You can also offer to post the images on your password-protected site.

YOU PRINT AND DISTRIBUTE

In your preliminary negotiations with your client you can also offer to provide them with prints. You can explain that you can provide high-quality images at a slightly better price than many places in your town. That will generate a little extra money without a significant outlay of your time.

You can also offer to post all of the images on your password-protected web site where all of their guests can view the images and select those they want printed. This is a much more time-consuming challenge, but you can then work with the client to control distribution; your options are: (1) to print out every request and turn them all over to the client for distri-

Golfers tend to want a picture of that perfect swing!

bution, or (2) to print and mail the images yourself. The second option requires a lot of bookkeeping and takes a lot of time without a significant increase in income.

Some corporations might be inclined to utilize your services in the printing and distribution of the prints. Why? It might be easier for them to send you a check for $500 or $1,000 to handle all of the paperwork involved in tracking orders, printing, preparing individual packets for several hundred people, mailing those packets out, and then fixing mistakes or sending additional prints. This is a complicated and time-consuming job, and it makes sense for a busy corporation to pay you to do this job. This option, though time consuming, is financially attractive.

YOUR FULFILLMENT CENTER PRINTS AND DISTRIBUTES

You have the option to register with a fulfillment center that allows you to assign passwords for specific events. The site will allow you to provide your clients with a variety of print sizes, print finishes, and supplemental sale items (such as a picture printed on a tee-shirt, coffee mug, baseball or basketball, mouse pad, towel, etc.). The fulfillment center has its base price for each item but gives you the freedom to select your own price for each image. For example, the center's price for a 5x7-inch print might be $0.98. You can sell your client this print for $1.98, giving you a $1.00 back. The customer will also, however, be charged for local sales taxes on the total order and a processing/mailing fee. The center may deduct a percentage of the total sales from the amount due you. You usually receive notification each time someone makes a purchase and you automatically receive a check in the mail at the end of each month.

This approach is fairly simple to run once you've done it a few times. It gives you many more opportunities to generate income, and it accomplishes the job of printing and distribution with minimal effort on your part, but with cash coming in to you each month. This is a tremendous benefit of the digital era.

You usually be notified each time someone makes a purchase.

12. Professional Conduct

Often when we meet with a new client for an assignment we have to listen to a litany of complaints about what the last photographer did or didn't do. The stories about the poor judgment or etiquette exercised by fellow photographers is amazing.

Being known for a high level of professionalism will pay dividends. To help you avoid some common mistakes, we've listed a few of the simplest things to do if you expect to get invited back to shoot another event.

DON'T KNOCK YOUR COMPETITION

Being known for a high level of professionalism will pay dividends.

When meeting with your clients for the first time (or any time for that matter), try not to bad-mouth a competitor, especially in a small, tightly knit community. The competitor will hear those negative comments, and you'll have made an enemy who will bad-mouth *your* photography. The best approach is to praise your competitor as a good photographer, but say that you feel you can provide better photographs, better service, or better prices. Do we use this approach? Yes. We feel very confident in our level of experience, our equipment is second to none, and we bring to the table a track record for success. On occasion, we will even offer up the name of one of our competitors

A good way to start off any public event is to include some of the workers at the event. In this case, it was the airport police at an open house at Dulles International Airport.

if we can't get the price we are asking for, with the tacit understanding that they will work for less because they don't share our credentials. You'd be surprised at how few clients take us up on that offer. We are, however, very complimentary about our competitors when we make that offer.

DON'T SMOKE

Yes, we know you've smoked since you were fifteen years old, and nonsmokers are out to make your life difficult. So, either stay at home and smoke or realize that most people today don't like smoke and that many establishments prohibit smoking. Hey, this is a simple rule: don't smoke.

DON'T DRINK

Of course there are waiters walking around offering you a glass of champagne; just don't accept. Don't ask the bartender for a shot of vodka or a bottle of

Lighting of the band included multicolored spotlights (camera left) and an on-camera Nikon SB-800 with a diffuser with the Nikon D3 set at ISO 6400. Jim shot this with a 17–55mm Nikon zoom lens with a setting of $1/80$ at f/5.6.

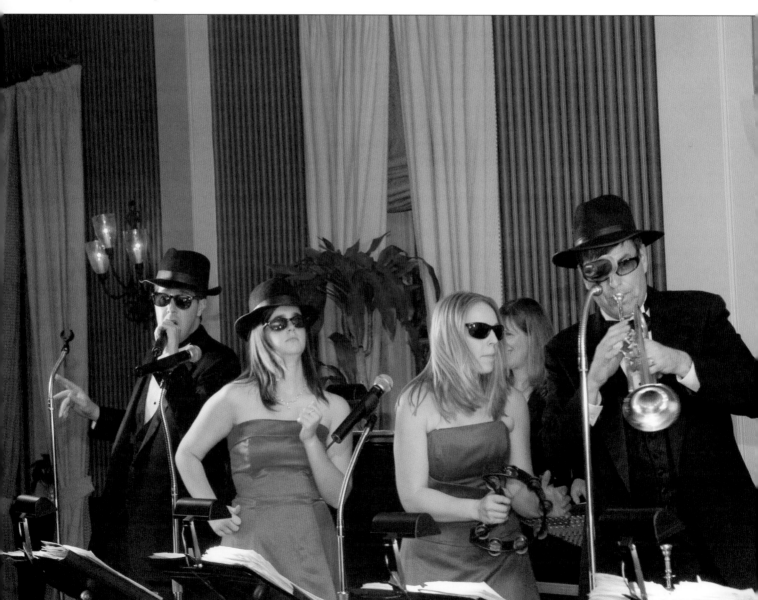

You are not being paid to get tipsy, high, or flat-out drunk.

Another favorite image. This was not a very difficult picture to take (bounced SB-28 with diffuser), but the colors simply pop, there are no shadows, and the male subject stands out against the background, thanks to a ceiling spotlight aimed at the wall. Nikon D200. Taken at f/5.6 with a shutter speed of 1/60 using a Nikon 35–70mm zoom lens.

beer. You are being paid to photograph. You are not being paid to get tipsy, high, or flat-out drunk. There's nothing wrong with accepting a bottle of water!

DON'T FLIRT WITH THE GUESTS

We've heard stories from clients about the photographer who spent most of his time chatting up the young women at the event instead of taking pictures. Maybe he got a date for the evening, but he lost a potential sale to the future client who was offended by his actions.

Having said this, it is important for you to communicate with everyone at the event, from the youngest child to the oldest person. Be polite, be friendly, but keep working. Sometimes a slightly intoxicated guest who wants to tell you about his collection of photographs or new camera or whatever will buttonhole you. Politely but firmly say that you are sorry, but you've just got to catch the action over at the other end of the room, and then walk away.

EAT ONLY IF OFFERED

Yes, you can take a canapé or some cheese, or even a shrimp or two. Just don't stand there eating all the shrimp while the guests are trying to get something to eat. Again, you are there to photograph, not to eat, drink, and be merry. Pack a sandwich and leave it in your car in case you get hungry.

Usually, once the guests have gone through a buffet line the host will ask if you'd like something to eat. That is your signal to accept the offer, put your camera down, and have something to eat while the other guests are also eating (photographs of people eating are usually not flattering). Also, don't load up your pocket with fried shrimp, cookies, and roast beef. It's just not good manners, and you are there to photograph, not to take advantage of a host's generosity.

If the function is a sit-down dinner, the caterer may offer to bring you a plate with something to eat. Sometimes you'll be invited to sit at a table where there are empty seats. Other times there will be a side room where you can sit. If offered, feel free to accept. Otherwise, just stay on your feet and keep on shooting.

> You should do your best to blend into the crowd, not stand out.

DRESS CONSERVATIVELY

You should do your best to blend into the crowd, not stand out because of your unusual taste in clothing. If you want to dress up in a wild outfit, then plan your own party. You have been invited to the event not as a guest, but as a photographer. We usually dress in black to avoid standing out in photographs where we are reflected in a mirror or glass. You can try for a dark suit or a blue blazer and gray slacks. Women photographers should follow the same dress standard, except it is best to wear slacks and shoes that keep you steady (i.e., no high heels).

PROPER GROOMING

Your pals may think you look rugged in your week's worth of facial hair, but other people might not—especially those who have spent a great deal of money to host an event. Bath? Obviously! Deodorant? Obviously! Wild hairdo? Save it for your party, not theirs.

LOSE THE ATTITUDE

Sometimes you simply have a bad hair day. When you do, leave the attitude at home and get on with it. I take photographs as a volunteer for my local police department. They participated in a National Night Out event that in-

volved several very large corporate sponsors. After the event, my police liaison asked me if I'd be willing to take photographs next year for one of the corporations who had hired a local photographer who was obnoxious to his clients, their guests, the event organizers, and to the public. Amazing!

ENJOY YOURSELF

Curiously, some people like it when the photographers relax and have some fun during the evening, sometimes dancing or singing or clowning around toward the end of the event. A couple times I've heard people say, "Even the photographer danced at our party." So, enjoy yourself, but remember why you are there: you are being paid to photograph others.

KEEP IN TOUCH

The last important rule is to make sure that the hostess sees you working, that she doesn't see you chatting up the ladies or with a bowl of shrimp under one arm and two bottles of beer under the other arm. Keep asking her if there is anyone or anything else that needs to be photographed. She will feel as if things are under her control and then can't come back the next week and complain that you failed to photograph Mr. and Mrs. So-and-So.

If you want to be especially thoughtful, consider sending the host and hostess a thank-you card after the event telling them what a wonderful party they gave. Don't include your invoice with the thank-you card.

We strive to make the product look beautiful.

13. Building on Success

EFFECTIVE USE OF YOUR IMAGES

The beauty of event photography is that it allows you to build on your successes. At each event you are likely to have several outstanding images depicting human interaction, images that stand out as exceptional. Each of those images can be added to your web site, portfolio, or used in other ways to promote your work.

We use images from our various events to keep our portfolios current. Some people enjoy seeing themselves on my web site, Jim's web site, or in our marketing portfolios—and we've yet to have any objections. When it comes to producing advertisements, however, we use only those images for which we have a signed model release.

If you cover enough events, you'll begin to bump into photographers and writers for your local newspapers. Take the time to nurture those contacts. We've developed a lot of contacts over the years, and occasionally we'll be asked if a paper can use our images of the event. If it is okay with the client (we always ask), then we'll e-mail them images and let the editor select those they want. In such a case, they have a final product on their desks by the next day. Having someone's event covered in a local newspaper is a bonus for clients, and the fact that we helped them hit the society pages does not go unnoticed. There are even times when we will call a contact with the newspaper and give them a "heads up" on an event we'll be covering; they may or may

> We use images from our various events to keep our portfolios current.

AN IMPORTANT NOTE

Because use of any recognizable feature in advertising could result in legal action, it is critical that you include a statement in your contract that allows you the specific right to use any or all of your images to promote your business.

This does not mean that you can take out a full-page advertisement showing some local dignitary who has had a bit too much to drink dancing around with a lampshade on his head. That will lead to a lawsuit and you are likely to lose your case, your money,

your house, and your newborn son! Don't do it!

Keep your promotional efforts limited to your web site and portfolio, and if anyone objects, simply remove the image in question.

If you find that you have such a great shot that you must use it in a form of advertising, then see if you can locate the individual(s) in the image and have them sign a model release. That may be hard to do in a large city but might be easier in a small town.

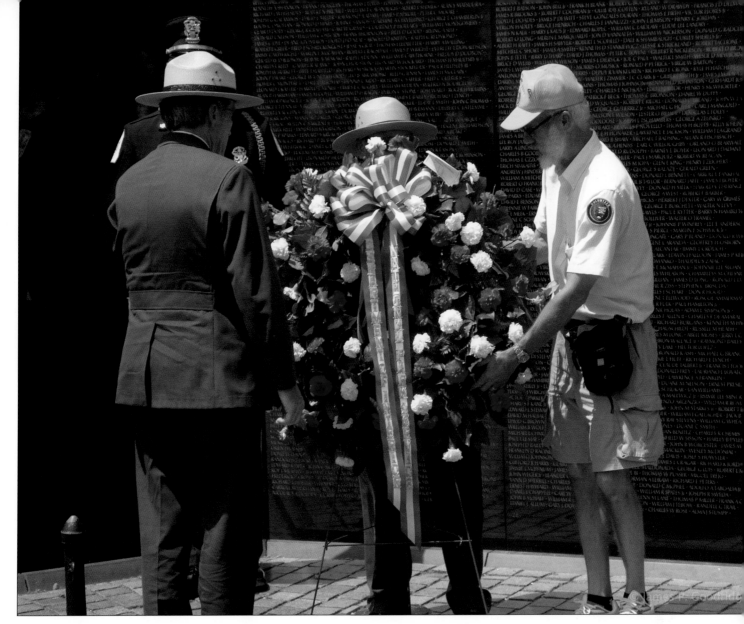

A wreath-laying ceremony on Memorial Day.

not cover the story, but at least they know we'll be taking really good images that they can use and that we are quick to get them publication quality images. Every time that happens, we get a publication credit.

BUILDING AN EVENT-SPECIFIC PORTFOLIO

You can't expect to have all of the images of the various events you must have when you first get started. Building a collection of really good images is a gradual process. Once you've done ten events, you should have enough images to build a very nice general portfolio. Then, over the course of a year or two, you might cover two county fairs, four business meetings, eighteen birthday parties, six religious ceremonies, ten ribbon cuttings, thirty sporting events, and fifteen community events. Now you have plenty of images to create event-specific portfolios, and you can begin to market your services on your web site as a photographer who specializes in those types of events. Even if you've only photographed eight birthday parties, you probably have five really super images from each event; that's forty different images! Fill in some

Blowing out the candles is important for all ages.

Your confidence will surge when you can provide an event-specific web site.

text repeating the words "birthday photography," come up with a list of related keywords, and devote a page to birthday photography. You can do the same with the other events from which you have a good selection of images.

Your confidence will surge when you can provide prospective clients with an event-specific web site, an event-specific digital portfolio to send out, and

a portfolio containing the latest and best images you can find. So, when some-one asks if you've ever photographed the opening of a new business in your local shopping mall, you can immediately say yes and show them the results.

INCREASING YOUR FEES

As you gain confidence, experience, and a reputation, it will be time for you to increase your fees. Obviously in the beginning you'll need to keep your fees low and aim for less critical assignments. For example, start by photo-graphing birthday parties in your neighborhood for just enough money to cover your cost of printing. You'll be learning how to use your equipment and how to organize, print, and distribute files and photographs. You'll also learn from your mistakes.

One day, you might decide to increase your fees from $10 for a birthday party to $20, and you can show your neighbors why the fee is worthwhile. Soon you'll be able to charge $50 for an assignment and maybe a bit more for producing larger prints. Before you know it you'll feel confident asking for $100 for a two-hour assignment—and on and on until you begin making fairly good money.

EXPANDING YOUR CLIENT BASE

As your reputation grows, word of mouth becomes one of your best market-ing tools. Here is where your professional ethics, grooming, ability to deal with customers, skill in handling problems, and photographic talent come to-gether. Never underestimate the importance of word-of-mouth endorsements.

Jim frequently talks of the need to "touch someone five times" before he/she becomes a client. Continue that tradition. After you have mailed off your invoice and CD, don't stop. Send the client a thank-you note. Send a card for the holidays. Ask them if they want to be informed when you have a special price for studio portraiture. Just try to keep them involved with you, so when the next event comes up they'll think of you first.

Never underestimate the importance of word-of-mouth endorsements.

14. Conclusion

Event photography can certainly add to the income of any photographer. Event photography allows beginners with a basic camera, flash, and lens to get started. You can expand your business as slowly or as quickly as you want, working at your own pace.

The songbook served as a reflector and helped illuminate the subject's face. The D2X was used with a 17–55mm Nikon zoom. Settings of ISO 400 and $\frac{1}{60}$ at f/4.5 were used. The lighting was produced by a bounced Q-Flash.

A GOOD SOURCE OF SUPPLEMENTAL INCOME

Event photography should be seen as a supplemental source of income. Despite nearly sixty years of photographic experience between the two of us, Jim and I still rely on our portrait business, commercial accounts (architectural and product photography), and wedding photography to bring in most of our income.

IT'S A CHALLENGE

One of the biggest developments in digital photography is that it has made photography so easy that many people feel they can take the pictures instead of asking a professional photographer to do the work. For our normal hourly fee, people can afford to buy an entry-level digital camera. For this reason, it has become increasingly difficult in recent years to find clients willing to pay our rates when they feel they can do an adequate job all by themselves.

Event photography can be tough for other reasons, too: There may only be one golf course in your town, and another photographer may have already gained control over photographing golf tournaments. Gaining a foothold takes a time and persistence, but gradually your skills will improve, and sooner or later the old guard will retire or move on, allowing you to step up.

A LONG-TERM INVESTMENT

You may have several young children and enjoy working with youngsters. Because you are willing to work for what other moms think is a reasonable price, you might be able to convince them to let you take photographs of their children as they grow. They will need photographs of their children heading off to kindergarten, joining the Cub Scouts, then Boy Scouts. They'll want images of the kids playing softball, baseball, or football. Later, they may call you to take their high school graduation pictures, prom night photos, and college graduation photos. As time goes on, the grown children will need engagement photos, wedding photos, baby photos, and birthday photos—and that will give you a reasonable source of income for the rest of your life.

> Gaining a foothold takes a lot of time and persistence.

IT'S WHAT YOU MAKE OF IT

Event photography allows you to pick and choose the types of photography you wish to cover. Perhaps you love photographing demolition derbies and you absolutely will not put on a coat and tie! Relax, you don't need to. Heck, you can show up in greasy overalls and you'll blend right in. Just don't be disappointed if you show up at a wedding in those same overalls and the mother of the bride lets out a shriek and faints on the spot.

FOCUS ON WHAT'S AVAILABLE

There are other obstacles to overcome. The gala season might be a bit on the sparse side in a farming community, but that same community might have lots of indoor events during the winter months and plenty of 4-H, county fairs, and harvest festivals. Those are your logical market.

TAKE YOUR TIME

Become a good photographer and a reliable contact in your community. Volunteer your services, even after you've gained a reputation for excellence. As you continue to expand your business, invest in the very best lenses you can find, then go for a better camera. Finally, purchase lights that will serve you well in a variety of situations.

Before you know it, perhaps in a few years, you'll be charging considerably more and enjoying your work which, by now, should be coming to you. You've arrived.

Taking good pictures of children is always a client pleaser and will keep clients coming back for photos for years to come.

Frequently Used Terms

This section is designed to help you understand commonly used photographic terms. The definitions are quite simple and are intended only as a starting point in your learning. More information can be readily found on the Internet or in general photography or image-editing books.

Adobe Photoshop. A software program that allows users to make image adjustments, including brightness and contrast alterations, color correction, removal of distracting image elements, and much more. *See also* Adobe Photoshop Elements.

Adobe Photoshop Elements. An entry level (or "light") version of Photoshop aimed toward consumers. The program costs much less than Photoshop but includes many of the same features.

aperture. An adjustable opening in a plate inside the lens that controls the amount of light that passes through the lens. The size of the opening is described in f-stops. *See also* f-stop.

aperture priority. A mode of operation in which you set your aperture and the camera automatically adjusts the shutter speed to produce a perfectly balanced exposure. *See also* shutter priority.

auto focus. The camera automatically locates the subject and, if properly synched to the flash, takes photographs that are in focus. This is particularly useful in low-light situations where the action is fast. Sometimes, however, in very low light the camera system will "hunt" for the subject, moving back and forth in an attempt to find and focus on the subject. When this is happening, you can't take a photograph.

automatic mode. The camera automatically adjusts both the shutter speed and aperture to produce a properly exposed photograph. *See also* program mode, aperture priority, *and* shutter priority.

B (Bulb). A shutter speed setting generally used with a cable release. The B setting keeps the shutter open until the cable is released. Good for night photography.

blur or blurring. (1) Refers to the soft, out-of-focus background produced when lower aperture (e.g., f/2) settings are used, or when using a telephoto lens up close, or when using an extension tube. A blurred background helps the subject stand out clearly. (2) Unsharpness that results from subject or camera movement as the exposure is made.

bounce flash. A technique used to avoid the "deer in the headlights" effect in portraits. The head of the flash unit swivels up (and around) to bounce the light off the ceiling, walls, or another element and onto subjects, resulting in more diffuse light and a more pleasing image.

bracketing. Producing multiple images at slightly different exposure settings to increase the odds of achieving an accurate exposure. This technique is useful when photographing predominantly black (dark) or white (light) subjects, such as a man in a black tuxedo or a woman in a white gown. Some cameras offer an auto bracketing option. Note that the camera's histogram can help you know when to increase or decrease the amount of light entering the camera.

center-weighted metering. A method used to measure the amount of light entering the camera. This information is derived from a sensor metering a spot in the middle of the focus screen and is used to set the right aperture and shutter speeds for an exposure. The area used in center-weighted metering is much smaller than the area used in spot metering. *See also* multiple-point metering *and* spot metering.

color mode. Some cameras allow you to take color, black & white, or sepia pictures.

depth of field. The area in front or behind the subject that is in focus. Low aperture settings have minimal depth of field; high aperture settings provide greater depth of field.

digital zoom. A simulated zoom effect whereby the camera's internal software enlarges an image area through interpolation. The process does not increase the focal length of the lens; therefore, there is a resultant loss of quality. *See also* optical zoom.

D-SLR. A single-lens-reflex camera that captures images on an image sensor rather than film. These are usually higher-end models, but camera makers are introducing less expensive cameras that allow you to change from a wide-angle lens to a telephoto lens at will.

fill flash. Use of flash equipment to illuminate shaded areas. Typically only a small amount of light is needed. Experiment with your flash unit on low power settings with diffusers. Try bouncing flash off reflectors or through white fabric or paper.

focal length multiplier. On cameras with an image sensor smaller than a 35mm film frame, a value used to calculate the effective focal length for a given lens. This value varies from camera to camera and can be located in the camera user's manual.

focus. The physical point at which rays of light from a lens converge to form a properly defined image of the subject.

f-stop. A number used to describe the relative size of the aperture opening, obtained by dividing the lens focal length by its effective aperture. Most lenses include standard openings of f/1.2, f/2, f/2.8, f/3.5, f/4, f/4.5, f/5.6, f/8, f/11, f/16, f/22, f/32, and f/62, and newer digital cameras allow you to use aperture settings between those shown above, such as f/6, f/6.5, etc. The smaller the f-stop number, the larger the opening. Aperture settings of f/2, for example, admit much more light than f/22. Also, an increase or decrease of a full f-stop either doubles or halves the aperture size, and thus the amount of light used to expose the film or image sensor. The term *f-stop* is sometimes used as a synonym for aperture. *See also* aperture.

histogram. A two-dimensional graph that shows the tonal distribution of pixels in an image. A digital image consists of pixels that can be divided into 256 levels of brightness: from black (0) to white (255) with 254 gray levels in between. The ideal histogram should resemble a bell curve. If the edges of the histogram do not extend all the way to both (or one) side, then the image is either under- or overexposed and you should use your +/− control to add or subtract light for your next image. Some cameras provide a histogram feature that allows you to review tonal distribution upon capture. Most image-editing programs do also.

ISO. The abbreviation for the International Standards Organization. This organization set international standards used by the film industry and now the digital industry to set film or digital sensitivity to light or the absence of light. ISO ratings under 100 ISO work best in bright daylight. Those in the 200 to 500 ISO range work nicely in shady conditions. ISOs above 1000 work well in dark conditions. High ISO ranges (over ISO 500) can produce digital noise.

image stabilization. *See* vibration reduction.

JPEG. A lossy compression algorithm that allows for the reduction in the amount of memory required for image storage. *See also* RAW *and* TIFF.

lag time. The time it takes from when the camera's shutter release button is pressed and the time the photo is actually taken. Early digital cameras suffered from long delays, resulting in missing the action.

LCD. Liquid Crystal Display. A screen on the back and/or top of digital cameras where you can see images, histograms, menu settings, or camera settings.

macro lens. A lens that allows you to get very close to your subject and take very detailed images up close. Not useful in event photography. *Some manufacturers call their macro lenses* micro lens; however, true micro lenses are usually used to photograph microscopic subjects.

manual mode. A nonautomatic mode of operation in which the photographer must select both the aperture and shutter speed. *See also* automatic mode, program mode, aperture priority, and shutter priority.

memory cards. A small, removable device on which image information captured by the sensor is stored. You can transfer those images to your computer, then reformat the card and start over with a clean card. With higher megabyte cameras you need larger storage capacity, such as 1MB, 2MB, 4MB or higher memory cards.

movie mode. Some digital cameras allow you to take short video-and-sound sequences that can be displayed on your computer or on a web site.

multiple-point metering. A method used to measure the amount of light entering the camera from several areas of the scene. The camera averages the information to provide a reading that will produce an accurate exposure. Also called matrix metering by Nikon, evaluative metering by Canon, and digital ESP by Olympus. *See also* center-weighted metering *and* spot metering.

noise. The appearance of unwanted colored pixels in parts of the image typically caused by temperature and the selection of high ISOs. Similar to grain that appeared in film prints when using film with a high ISO rating.

open up. To increase the aperture setting (e.g., go from f/8 to f/5.6) to admit more light.

optical zoom. A feature that allows you to focus on a single part of a scene and enlarge it. Optical zoom uses a combination of lenses to magnify the scene before it is registered on film or the image sensor. This feature produces better results than digital zoom. *See also* digital zoom.

panorama mode. A feature available in some cameras that facilitates the shooting and alignment of images that can be "stitched together" using computer software to produce a panoramic image.

pixel. From "picture element," a tiny square about 6 microns wide that contains visual information about brightness and color. A million pixels equals one megapixel. You need over ten megapixels to reach the level of quality produced by film.

playback mode. Allows you to see all of the images you've taken by scrolling backward or forward and watching the images on the camera's LCD screen. *See also* LCD.

program mode. A shooting mode in which the camera automatically adjusts both the shutter speed and aperture to produce a properly exposed photograph. Unlike automatic mode, program mode allows the photographer to override some of the settings. *See also* automatic mode, aperture priority, *and* shutter priority.

Q-Flash. A flash system sold by Quantum Instruments that produces beautiful light with enough power to fill a large room. Used both on-camera and off-camera when equipped with radio-controlled transmitters and

receivers and/or slave units. You will require a battery pack to operate the system.

RAW. A proprietary file format that records image information without any compression or loss of information. You are able to make adjustments to RAW images that do not alter the basic image histogram. Creates very large file sizes. *See also* JPEG *and* TIFF.

red-eye. The red glow that appears in the eyes of human subjects when the flash hits the subject's retina and bounces straight back into the lens. Red-eye can be avoided if the flash is raised over the camera using a mount or by selecting the red-eye tool in the flash setup. That setup will usually cause several fast pulses of light to be emitted, which hopefully will cause the iris of the subject to contract, lessening the degree of red-eye seen. You can also use software programs, such as Adobe Photoshop, to remove red-eye after the event.

rule of thirds. A general compositional principle in which the image is sectioned into thirds horizontally and vertically (e.g., like a tic-tac-toe board). The rule states that subjects should be placed at one of three lines, or better still, at one of the four points where the horizontal and vertical lines intersect. Unfortunately, most people photographed during an event end up in the middle of the image because you rarely have time to compose artistic images.

shutter priority. An exposure mode in which the photographer selects the desired shutter speed and the camera automatically selects the aperture that will produce an acceptable exposure. *See also* aperture priority.

shutter speed. The speed at which the camera's shutter opens and closes. This controls the amount of light that is recorded. Shutter speeds range from several minutes ("B" for bulb setting) to $\frac{1}{10,000}$ second or higher. Slow shutter speeds register motion, and fast shutter speeds stop motion. Low shutter speeds permit the use of higher f-stops (e.g., f/22); high shutter speeds require low f-stops (e.g., f/2).

spot metering. Measuring from a very narrow angle the light reflected light from a small area of the subject. *See also* center-weighted *and* multiple-point metering.

step/stop down. Reducing the size of the aperture setting (e.g., go from f/8 to f/11) to admit less light.

telephoto lens. A high-powered lens similar to the lenses used in binoculars. Attaches to your camera and

allows you to take close-ups of distant objects. Usually cannot focus on subjects within a few feet of the camera. *See also* zoom-telephoto lens *and* zoom-micro lens.

TIFF (Tagged Image File Format). A widely used raster image file format. The format supports LZW compression, but the images can also be saved uncompressed (in such a case, the files are very large). *See also* JPEG *and* RAW.

TTL metering. Through-the-lens metering system that uses sensors built into the camera body to meter the same light in the scene that you see when you look through the viewfinder.

vibration reduction. A computerized system that allows the lens to compensate for small camera movements. This can improve your odds of producing sharp images when handholding your camera. Synonymous with image stabilization.

white balance. A feature of digital cameras that allows the user to neutralize color casts produced in various light conditions (e.g., tungsten, shade, full sun, flash).

wide-angle lens. A lens with a focal length longer than the diagonal of the film frame or image sensor. It provides a wider perspective than a normal lens. These lenses can produce very sharp images, are often used in landscape work, and are a great option in many event photography sessions.

zoom-micro telephoto lens. A lens that allows you to zoom in and out (from near to far). The micro-elements of the lens allow you to focus on subjects that are very close to the camera. A valuable lens for any event photographer, but they are expensive if you demand the best.

zoom-telephoto lens. A lens that allows you to zoom in and out (from near to far), but the lens does not work at close distances. Great for event photography.

Index

MASTER LIGHTING GUIDE FOR
PORTRAIT PHOTOGRAPHERS

Christopher Grey

Efficiently light executive and model portraits, high and low key images, and more. Master traditional lighting styles and use creative modifications that will maximize your results. $29.95 list, 8.5x11, 128p, 300 color photos, index, order no. 1778.

MASTER LIGHTING TECHNIQUES
FOR OUTDOOR AND LOCATION DIGITAL PORTRAIT PHOTOGRAPHY

Stephen A. Dantzig

Use natural light alone or with flash fill, barebulb, and strobes to shoot perfect portraits all day long. $34.95 list, 8.5x11, 128p, 175 color photos, diagrams, index, order no. 1821.

THE BEST OF PROFESSIONAL DIGITAL PHOTOGRAPHY

Bill Hurter

Digital imaging has a stronghold on photography. This book spotlights the methods that today's photographers use to create their best images. $34.95 list, 8.5x11, 128p, 180 color photos, 20 screen shots, index, order no. 1824.

PROFESSIONAL PORTRAIT LIGHTING
TECHNIQUES AND IMAGES FROM MASTER PHOTOGRAPHERS

Michelle Perkins

Get a behind-the-scenes look at the lighting techniques employed by the world's top portrait photographers. $34.95 list, 8.5x11, 128p, 200 color photos, index, order no. 2000.

MASTER POSING GUIDE
FOR CHILDREN'S PORTRAIT PHOTOGRAPHY

Norman Phillips

Create perfect portraits of infants, tots, kids, and teens. Includes techniques for standing, sitting, and floor poses for boys and girls, individuals, and groups. $34.95 list, 8.5x11, 128p, 305 color images, order no. 1826.

RANGEFINDER'S PROFESSIONAL PHOTOGRAPHY

edited by Bill Hurter

Editor Bill Hurter shares over one hundred "recipes" from *Rangefinder's* popular cookbook series, showing you how to shoot, pose, light, and edit fabulous images. $34.95 list, 8.5x11, 128p, 150 color photos, index, order no. 1828.

LEGAL HANDBOOK FOR PHOTOGRAPHERS, 2nd Ed.

Bert P. Krages, Esq.

Learn what you can and cannot photograph, how to handle conflicts should they arise, how to protect your rights to your images in the digital age, and more. $34.95 list, 8.5x11, 128p, 80 b&w photos, index, order no. 1829.

MASTER'S GUIDE TO WEDDING PHOTOGRAPHY
CAPTURING UNFORGETTABLE MOMENTS AND LASTING IMPRESSIONS

Marcus Bell

Learn to capture the unique energy and mood of each wedding and build a lifelong client relationship. $34.95 list, 8.5x11, 128p, 200 color photos, index, order no. 1832.

MASTER LIGHTING GUIDE
FOR COMMERCIAL PHOTOGRAPHERS

Robert Morrissey

Use the tools and techniques pros rely on to land corporate clients. Includes diagrams, images, and techniques for a failsafe approach for shots that sell. $34.95 list, 8.5x11, 128p, 110 color photos, 125 diagrams, index, order no. 1833.

HOW TO TAKE GREAT DIGITAL PHOTOS
OF YOUR FRIEND'S WEDDING

Patrick Rice

Learn the skills you need to supplement the photos taken by the hired photographer and round out the coverage of your friend's wedding day. $17.95 list, 8.5x11, 80p, 80 color photos, index, order no. 1834.

DIGITAL CAPTURE AND WORKFLOW
FOR PROFESSIONAL PHOTOGRAPHERS

Tom Lee

Cut your image-processing time by fine-tuning your workflow. Includes tips for working with Photoshop and Adobe Bridge, plus framing, matting, and more. $34.95 list, 8.5x11, 128p, 150 color images, index, order no. 1835.

THE PHOTOGRAPHER'S GUIDE TO
COLOR MANAGEMENT
PROFESSIONAL TECHNIQUES FOR CONSISTENT RESULTS

Phil Nelson

Learn how to keep color consistent from device to device, ensuring greater efficiency and more accurate results. $34.95 list, 8.5x11, 128p, 175 color photos, index, order no. 1838.

SOFTBOX LIGHTING TECHNIQUES
FOR PROFESSIONAL PHOTOGRAPHERS

Stephen A. Dantzig

Learn to use one of photography's most popular lighting devices to produce soft and flawless effects for portraits, product shots, and more. $34.95 list, 8.5x11, 128p, 260 color images, index, order no. 1839.

CHILDREN'S PORTRAIT PHOTOGRAPHY HANDBOOK

Bill Hurter

Packed with inside tips from industry leaders, this book shows you the ins and outs of working with some of photography's most challenging subjects. $34.95 list, 8.5x11, 128p, 175 color images, index, order no. 1840.

JEFF SMITH'S LIGHTING FOR OUTDOOR AND LOCATION PORTRAIT PHOTOGRAPHY

Learn how to use light throughout the day—indoors and out—and make location portraits a highly profitable venture for your studio. $34.95 list, 8.5x11, 128p, 170 color images, index, order no. 1841.

PROFESSIONAL PORTRAIT POSING
TECHNIQUES AND IMAGES FROM MASTER PHOTOGRAPHERS

Michelle Perkins

Learn how master photographers pose subjects to create unforgettable images. $34.95 list, 8.5x11, 128p, 175 color images, index, order no. 2002.

MONTE ZUCKER'S
PORTRAIT PHOTOGRAPHY HANDBOOK

Acclaimed portrait photographer Monte Zucker takes you behind the scenes and shows you how to create a "Monte Portrait." Covers techniques for both studio and location shoots. $34.95 list, 8.5x11, 128p, 200 color photos, index, order no. 1846.

DIGITAL PHOTOGRAPHY FOR CHILDREN'S AND FAMILY PORTRAITURE, 2nd Ed.

Kathleen Hawkins

Learn how staying on top of advances in digital photography can boost your sales and improve your artistry and workflow. $34.95 list, 8.5x11, 128p, 195 color images, index, order no. 1847.

MASTER GUIDE FOR TEAM SPORTS PHOTOGRAPHY

James Williams

Learn how adding team sports photography to your repertoire can help you meet your financial goals. Includes technical, artistic, organizational, and business strategies. $34.95 list, 8.5x11, 128p, 120 color photos, index, order no. 1850.

POSING TECHNIQUES FOR PHOTOGRAPHING MODEL PORTFOLIOS

Billy Pegram

Learn to evaluate your model and create flattering poses for fashion photos, catalog and editorial images, and more. $34.95 list, 8.5x11, 128p, 200 color images, index, order no. 1848.

THE ART OF PREGNANCY PHOTOGRAPHY

Jennifer George

Learn the essential posing, lighting, composition, business, and marketing skills you need to create stunning pregnancy portraits your clientele can't do without! $34.95 list, 8.5x11, 128p, 150 color photos, index, order no. 1855.

BIG BUCKS SELLING YOUR PHOTOGRAPHY, 4th Ed.

Cliff Hollenbeck

Build a new business or revitalize an existing one with the comprehensive tips in this popular book. Includes twenty forms you can use for invoicing clients, collections, follow-ups, and more. $34.95 list, 8.5x11, 144p, resources, business forms, order no. 1856.

ILLUSTRATED DICTIONARY OF PHOTOGRAPHY

Barbara A. Lynch-Johnt & Michelle Perkins

Gain insight into camera and lighting equipment, accessories, technological advances, film and historic processes, famous photographers, artistic movements, and more with the concise descriptions in this illustrated book. $34.95 list, 8.5x11, 144p, 150 color images, order no. 1857.

PROFESSIONAL PORTRAIT PHOTOGRAPHY

TECHNIQUES AND IMAGES FROM MASTER PHOTOGRAPHERS

Lou Jacobs Jr.

Veteran author and photographer Lou Jacobs Jr. interviews ten top portrait pros, sharing their secrets for success. $34.95 list, 8.5x11, 128p, 150 color photos, index, order no. 2003.

EXISTING LIGHT

TECHNIQUES FOR WEDDING AND PORTRAIT PHOTOGRAPHY

Bill Hurter

Learn to work with window light, make the most of outdoor light, and use fluorescent and incandescent light to best effect. $34.95 list, 8.5x11, 128p, 150 color photos, index, order no. 1858.

THE SANDY PUC' GUIDE TO

CHILDREN'S PORTRAIT PHOTOGRAPHY

Learn how Puc' handles every client interaction and session for priceless portraits, the ultimate client experience, and maximum profits. $34.95 list, 8.5x11, 128p, 180 color images, index, order no. 1859.

MINIMALIST LIGHTING

PROFESSIONAL TECHNIQUES FOR LOCATION PHOTOGRAPHY

Kirk Tuck

Use small, computerized, battery-operated flash units and lightweight accessories to get the top-quality results you want on location! $34.95 list, 8.5x11, 128p, 175 color images and diagrams, index, order no. 1860.

THE KATHLEEN HAWKINS GUIDE TO

SALES AND MARKETING FOR PROFESSIONAL PHOTOGRAPHERS

Learn how to create a brand identity that lures clients into your studio, then wow them with outstanding customer service and powerful images that will ensure big sales and repeat clients. $34.95 list, 8.5x11, 128p, 175 color images, index, order no. 1862.

SIMPLE LIGHTING TECHNIQUES

FOR PORTRAIT PHOTOGRAPHERS

Bill Hurter

Make complicated lighting setups a thing of the past. In this book, you'll learn how to streamline your lighting for more efficient shoots and more natural-looking portraits. $34.95 list, 8.5x11, 128p, 175 color images, index, order no. 1864.

PHOTOGRAPHER'S GUIDE TO

WEDDING ALBUM DESIGN AND SALES, 2nd Ed.

Bob Coates

Learn how industry leaders design, assemble, and market their outstanding albums with the insights and advice provided in this popular book. $34.95 list, 8.5x11, 128p, 175 full-color images, index, order no. 1865.

LIGHTING FOR PHOTOGRAPHY TECHNIQUES FOR

STUDIO AND LOCATION SHOOTS

Dr. Glenn Rand

Gain the technical knowledge of natural and artificial light you need to take control of every scene you encounter and produce incredible photographs. $34.95 list, 8.5x11, 128p, 150 color images/diagrams, index, order no. 1866.

ARTISTIC TECHNIQUES WITH ADOBE® PHOTOSHOP® AND COREL® PAINTER®

Deborah Lynn Ferro

Flex your creativity and learn how to transform photographs into fine-art masterpieces. Step-by-step techniques make it easy! $34.95 list, 8.5x11, 128p, 200 color images, index, order no. 1806.

MASTER GUIDE FOR

UNDERWATER DIGITAL PHOTOGRAPHY

Jack and Sue Drafahl

Make the most of digital! Jack and Sue Drafahl take you from equipment selection to underwater shooting techniques. $34.95 list, 8.5x11, 128p, 250 color images, index, order no. 1807.

PROFESSIONAL POSING TECHNIQUES FOR WEDDING AND

PORTRAIT PHOTOGRAPHERS

Norman Phillips

Master the techniques you need to pose subjects successfully—whether you are working with men, women, children, or groups. $34.95 list, 8.5x11, 128p, 260 color photos, index, order no. 1810.

THE BEST OF FAMILY PORTRAIT PHOTOGRAPHY

Bill Hurter

Acclaimed photographers reveal the secrets behind their most successful family portraits. Packed with award-winning images and helpful techniques. $34.95 list, 8.5x11, 128p, 150 color photos, index, order no. 1812.

BLACK & WHITE PHOTOGRAPHY
TECHNIQUES WITH ADOBE® PHOTOSHOP®

Maurice Hamilton

Become a master of the black & white digital darkroom! Covers all the skills required to perfect your black & white images and produce dazzling fine-art prints. $34.95 list, 8.5x11, 128p, 150 color/b&w images, index, order no. 1813.

NIGHT AND LOW-LIGHT
TECHNIQUES FOR DIGITAL PHOTOGRAPHY

Peter Cope

With even simple point-and-shoot digital cameras, you can create dazzling nighttime photos. Get started quickly with this step-by-step guide. $34.95 list, 8.5x11, 128p, 100 color photos, index, order no. 1814.

PROFESSIONAL MARKETING & SELLING TECHNIQUES FOR
DIGITAL WEDDING PHOTOGRAPHERS
2nd Ed.

Jeff Hawkins and Kathleen Hawkins

Taking great photos isn't enough to ensure success! Become a master marketer and salesperson with these easy techniques. $34.95 list, 8.5x11, 128p, 150 color photos, index, order no. 1815.

MASTER COMPOSITION
GUIDE FOR DIGITAL PHOTOGRAPHERS

Ernst Wildi

Composition can truly make or break an image. Master photographer Ernst Wildi shows you how to analyze your scene or subject and produce the best-possible image. $34.95 list, 8.5x11, 128p, 150 color photos, index, order no. 1817.

THE BEST OF ADOBE® PHOTOSHOP®

Bill Hurter

Rangefinder editor Bill Hurter calls on the industry's top photographers to share their strategies for using Photoshop to intensify and sculpt their images. $34.95 list, 8.5x11, 128p, 170 color photos, 10 screen shots, index, order no. 1818.

HOW TO CREATE A HIGH PROFIT PHOTOGRAPHY BUSINESS
IN ANY MARKET

James Williams

Whether your studio is in a rural or urban area, you'll learn to identify your ideal client, create the images they want, and watch your financial and artistic dreams spring to life! $34.95 list, 8.5x11, 128p, 200 color photos, index, order no. 1819.

MASTER LIGHTING TECHNIQUES
FOR OUTDOOR AND LOCATION DIGITAL PORTRAIT PHOTOGRAPHY

Stephen A. Dantzig

Use natural light alone or with flash fill, barebulb, and strobes to shoot perfect portraits all day long. $34.95 list, 8.5x11, 128p, 175 color photos, diagrams, index, order no. 1821.

THE BEST OF PROFESSIONAL DIGITAL PHOTOGRAPHY

Bill Hurter

Digital imaging has a stronghold on photography. This book spotlights the methods that today's photographers use to create their best images. $34.95 list, 8.5x11, 128p, 180 color photos, 20 screen shots, index, order no. 1824.